A Brush with God

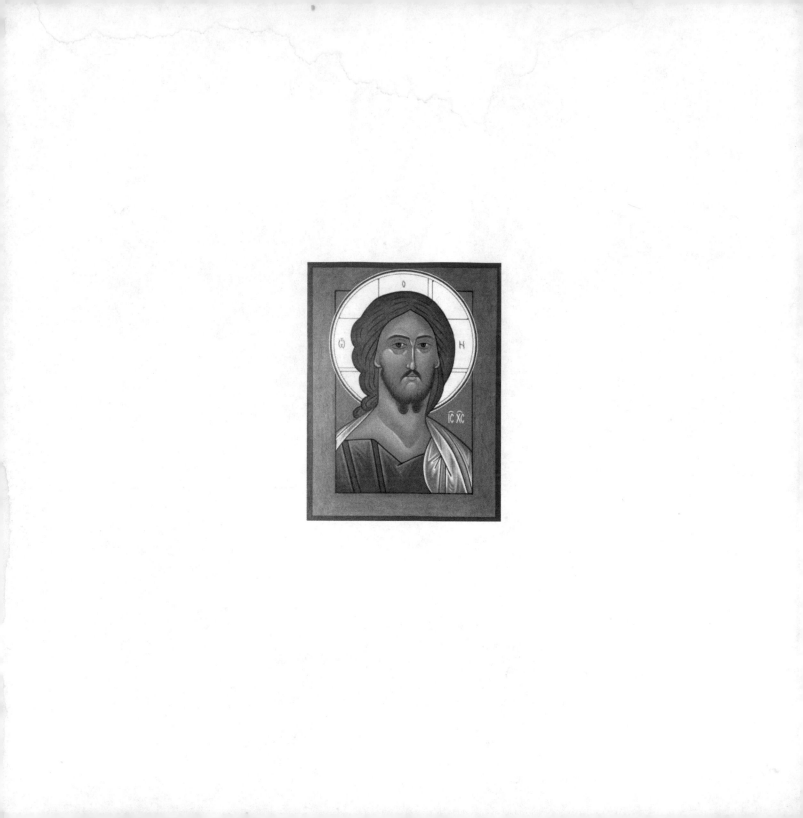

A Brush
—with—
GOD

An Icon Workbook

PETER PEARSON

MOREHOUSE PUBLISHING

Morehouse Publishing, P.O. Box 1321, Harrisburg, PA 17105

Morehouse Publishing is an imprint of Church Publishing, Inc.

Cover and interior design by Laurie Klein Westhafer

Icons photographed by Dennis Stefan

Library of Congress Cataloging-in-Publication Data

Pearson, Peter (Peter F.)
A brush with God : an icon workbook / Peter Pearson.
p. cm.
Includes bibliographical references (p.).
ISBN 0-8192-2203-8 (pbk.)
1. Icon painting—Technique. I. Title.
N8188.P43 2005
751.45'482—dc22
2005004476

Printed in the United States of America

06 07 08 09 10 9 8 7 6 5 4 3

———

This book is dedicated to the glory of God,
and in memory of Miss Joan Collins,
my art teacher from Lincoln Elementary School,
who first introduced me to icons,
and to all my teachers.
Thank you for everything.

———

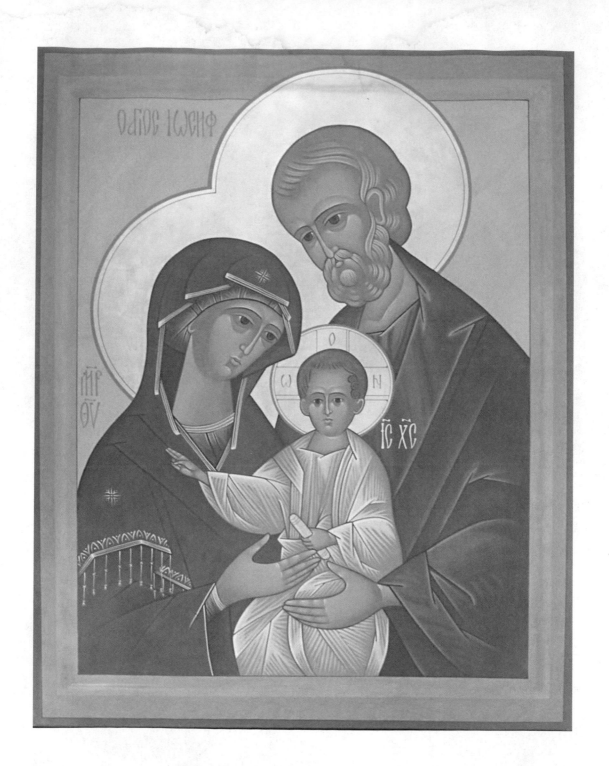

— Contents —

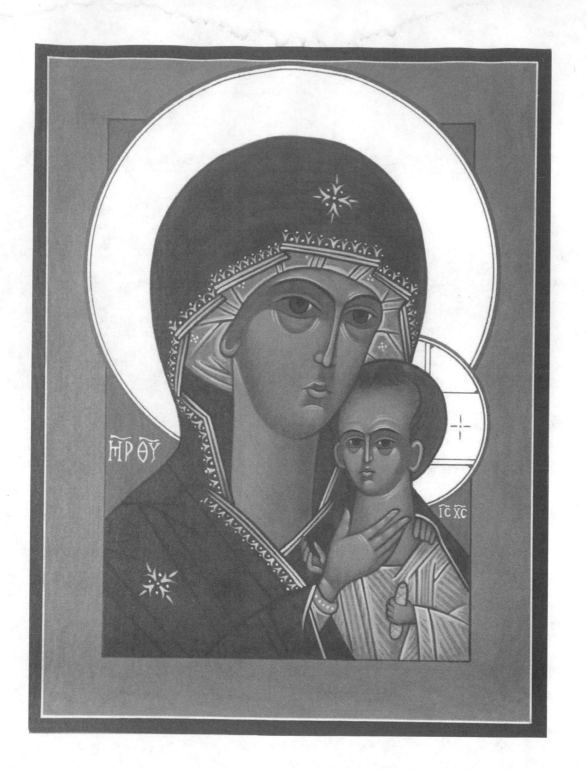

— FOREWORD —

The celebrant's introductory words for the "Order for the Blessing of an Image of our Lord Jesus Christ" in the *Book of Blessings* (the Roman Ritual)[1] state:

> *This image honors, above all, the truth that Christ is the visible image of the invisible God . . . the sign and sacrament of God the Father. As Christ himself said: "He who sees me sees the Father." Therefore, when we honor [his] image, let us lift up our eyes to Christ, who reigns for ever with the Father and the Holy Spirit.*

The ministry of the icon painter is that of the theologian: first, to know and love God; second, to praise God; third, to reflect on one's own experience of God from within a community of praise and present that reflection for the community's deeper understanding of its Faith, leading to greater praise of the Trinity that grounds all communion. Peter Pearson is a theologian who writes with paint on boards.

I first met Peter Pearson when he was playing the guitar with a folk ensemble at Blessed Sacrament Parish in Arlington, Virginia. I soon discovered that in addition to his day job (his own passport and visa service) he also painted icons. At the time, I was serving in a Melkite (Antiochian Byzantine Catholic) parish where I was being soaked in a very experiential way in the tradition and spirituality of the Eastern churches. From the first, I was deeply impressed by Peter's work and by both his intuitive and acquired knowledge and understanding of traditional iconography. I have followed his progress over the years and sat in his icon painting retreats. Eventually, I commissioned Peter to paint the icon of the Theotokos that graces our abbey church and I have come to see what a great master Peter has become. He instructs and guides. He gives encouragement. He invites the courage to take risks and be forgiving of one's mistakes. Indeed, from his own experience he teaches that mistakes can be some of our best teachers.

In this book, Peter demonstrates what he has learned at the levels of the head, the heart, and the hands. At the end of the Little Entrance in the Byzantine Divine Liturgy (Eucharist), the priest standing before the Royal Doors lifts the Gospel Book and sings aloud "Sophia, orthi!" (Wisdom, attend!). *A Brush with God* is about wisdom. It is about the wisdom of coming back to the truth that all ministry is a matter of competent skills informed by Faith. The competent skills Peter brings to his work and to his writing are a thorough knowledge of traditional iconography—years of learning through study and experience—and a deep Faith in that Incarnation that is the ground and justification for creating sacred images.

Peter's technical knowledge, skill, and experience are clearly seen in the chapters of this book, which stand out as the writing of a painter whose work has become prayer. Chapter 4, more than just an introduction to painting techniques, could well be an introduction to self-spiritual direction.

As a pastoral liturgist, I am most excited about Peter's insights concerning the ways sacred images might influence our understanding of theological and even scriptural texts. His clear explication of the Eastern canon of painting is a contribution to the faith life of Christians bombarded and saturated by a world of images that seduce us into conspicuous consumption rather than lead us to reflective thanksgiving. The boundaries imposed on the painter of icons come to be seen as conducive to good art and theology as the boundaries for writing a sonnet, a haiku, a hymn tune, a homily, general intercessions for public prayer, or a commentary on the Scriptures.

As a traveler, I have often found it beneficial to read as much as I can before journeying to a new land or city. When I return, I often reread some of the materials I read before setting out. *A Brush with God* serves well for that kind of reading. It is instructive reading for anyone drawn to icons. To simply absorb Peter's sage words about "gazing" will permanently transform the way the reader looks at icons and the human face. For those who have never painted an icon but are considering doing so, this work will be good tourist reading—an encouragement, a good overview of the territory, and a source of mining what they've acquired in the experience of painting. For those who have been painting icons, this book will be a helpful source of suggestions and a way of understanding anew their own brush with God.

Feast of the Transfiguration, August 6, 2003
Rev. Andrew D. Ciferni, O.Praem., Ph.D.
Rector of the Abbey Church and Liturgy Director
Daylesford Abbey, Paoli, PA

I grew up in a fairly typical Irish Catholic home, which means I grew up with plenty of old plaster statues. You probably know the ones I mean. Mary wore the baby blue robe and her nose was usually chipped. Jesus wore the white robe with a red cloak. And of course, there were holy cards, rendered in a quasi-Victorian manner. One picture of Jesus hung in the living room and there was a crucifix over the doorway in each bedroom, which I think was a compromise between my Catholic mother and my Baptist father. But my maternal grandparents lived right next door and their home was adorned with all the typical Catholic accessories, right down to the portrait of the pope and a flower vase bearing the image of Jacqueline Kennedy. In the 1960s, you couldn't get much more Catholic than that.

I was twelve years old when I saw my first icon. My elementary school art teacher, Miss Joan Collins, had invited me to her house for lunch. Walking into her living room, I was immediately drawn to an odd picture on the wall. It was a silk-screened Christmas card, a reproduction of an old Russian icon of the Virgin with three hands by Dr. June Baskin. I was completely taken by this image.

During the late sixties, icons were not given much attention on any front, either artistic or religious. I asked as many questions as was humanly possible during the time available, but since my teacher didn't know a great deal about icons, she suggested I visit the local library and pointed me in the direction of Byzantine art. I started my search the very next day. There were very few books about icons or, for that matter, Byzantine art. But, there were enough for me to make a start. And so, I read everything the library had on hand and began to experiment by piecing together the scant information the books provided.

My mother, meanwhile, had come to the end of her ceramics venture, so there was plenty of paint and no shortage of brushes. My dad brought home felt-tipped markers from work. I began by tracing images I found in the library books, mostly of mosaics from the churches and monasteries throughout the Middle East. I fashioned panels by stretching paper over the covers of old books, the backing of paper tablets or any other cardboard I could find. When my icons were completed, I created chapels in the nooks and crannies of our old house. They looked beautiful in the light of the candles I would burn before them.

I eventually graduated to wooden panels. Over these I stretched the athletic tape discarded by our high school basketball team, and applied a flour and glue mixture over the canvas taping. I had received a set of acrylic paints that Christmas, so I was thoroughly equipped for iconography.

Throughout high school, in my many art classes, I turned every sketch and painting that I was asked to do into an icon. Some teachers became frustrated, saying that I had settled on a style before honing my skills. Still, I painted icons.

One glorious year, a friend of my father's actually made me about a dozen wooden panels on which to paint—one of the best Christmas presents I ever got. Another Christmas, my father gave me a copy of the Strogonov School's Icon Painting Manual that he had found. I spent hours in my room and then in the studio I created in our attic, painting icons. In high school, I found doors from some old kitchen cabinets with inset panels. They were perfect for icons because they looked just like panels in the library books. I remember painting an icon of Christ on one of them, carefully gluing macramé cord into a pattern on the background—orange macramé cord!

When I went off to college seminary, I continued to paint whenever I had a moment. Often, I'd paint throughout the night. I experimented with composition gold leaf. And because I didn't know how to glue the leaf down, I created a technique almost like wall papering, gluing under—and over—the leaves. So what if the gold finish was a little murky, it was a start.

Today, a color photocopy of an icon I painted about thirty years ago is ever present in my studio. It's rather unskilled by my current standards, but it was the very best I could do at the time and it helps me remember not only that time of beginning, but the journey along the way.

It wasn't until I was in my mid-thirties that I took the plunge and began working full time as an iconographer—I didn't quit my day job until the time was right. When I decided to leave my monastic community, I also decided to give myself over to painting icons with undivided focus. Fortunately, I was completely free to do so since leaving the monastic enclosure meant I had nothing and therefore had nothing to lose. It was liberating and also very scary. People of faith know that there are no coincidences and I am living proof of that. Looking back, I can see how everything I've done in my professional and scholastic life has prepared me for this vocation.

As you join me in the tradition of iconography, please know that you have undertaken to do something that is genuinely challenging—and not just in the area of technique. As you paint, be prepared to learn some truly significant spiritual lessons that apply to every other aspect of your life. Entering the world of Byzantine iconography is a daunting task; there's so much to learn, it could easily take a lifetime to get only slightly past the surface. Perhaps the most essential attitude to bring to this adventure is one of humility—a spiritual virtue that's greatly misunderstood. As the root of the word suggests, humility is grounded (hummus) in reality. Humility is not self-deprecation but the ability to grasp clearly "what is" without the excess baggage of ego. The ego—that habitual self-centeredness we all struggle with—takes on many forms. It's subtle and sly and unrelenting. The

Gospels challenge iconographers, like all Christians, to abandon themselves to the journey that lies ahead. And this requires humility.

The primary role of the iconographer is one of service, offered first of all to God. Technical skill alone is not enough; prayer is an essential element in the process. Icons—real icons—emerge as the fruit of a life of prayer and invite others into an encounter with God through prayer. Our service, then, extends to all who come to pray before the image that we've created. Like the ancient monks who copied the Gospels, we render the Good News in color and line. And, just as the monks of old were not authorized to alter the text according to their own imaginations, we are not licensed to create images of Christ the Theotokos, the angels, or the saints according to our private imaginations. Plan, therefore, to leave your ego at the door of your studio. At every step, do the very best you can. Let go of the need to control things.

My best advice? Allow yourself to be present. Let all thoughts, ideas, and even feelings go with each moment. Never mind what lies ahead or what has gone before. As you paint, allow God to hold the concerns you carry in your heart.

Remember, too, that an icon is not—and cannot—be created by the sheer force of will. Seek to become an instrument through which God can create something wonderful. For this to happen, you may have to suspend the judgments, letting go of your need to create the best icon this world has ever seen. While you're at it, let go the fear of creating something ghastly. Keep in mind that an icon is a prayer and only God can judge the quality of a prayer. Therefore, be gentle with yourself and what you are about to create. Let this time of painting and prayer be eternity, the ongoing now in which God exists. All of us who share a passion for icons are entrusted with an ancient tradition that we can explore but never exhaust. What I offer here is iconography as seen through the filter of my own life and practice. I invite you to consider what I've learned in the hope that it will serve you in your own journey and ultimately serve the Gospel that Byzantine iconography strives to proclaim.

— CHAPTER ONE —
The Spiritual Practice of Iconography

I cons challenge our perception of what is real. They help us understand that our perceptions are often elusive and illusory. They provide a dramatically different view of things than what we can learn through our senses. Proclaiming a reality and beauty far greater than any we have ever experienced, they challenge us to reconsider what we believe based on our senses.

Icons offer us a glimpse into things through God's eyes and invite us to enter into the mystery of a world made new by the light of God's presence. With their glowing colors and graceful lines, icons insist that God is greater than any human fear and that we, too, are meant for glory.

> In spirituality of almost every kind, you'll find a discussion of "ego," the self-consciousness with which we live out most of our life. Contrary to popular opinion, ego does not always tell us that we're more important or perfect than we really are. Sometimes it abuses us with unrealistic ideas about our unworthiness and the depths of our faults. In either case, ego tells us that our ideas about self worth reflect some kind of ultimate reality. I recently came across a refrigerator magnet that boldly declares: "Don't believe everything you think!"
>
> In reality, most of us are rather ordinary—a mix of goodness and evil, beauty and ugliness, talent and lack thereof. If we can accept this, getting on with the business of life, things will be much more serene. In spiritual life, which encompasses iconography, ego is something that only gets in the way. Now, the challenge we face is how to minimize ego in our lives. As for in our painting, it's probably best to remember that we are servants to the story as it has been told for two thousand years . . . pick up a brush and get on with it.

ICONS AND IMAGES

Translated literally, "icon" means "image." In the context of Byzantine art, an icon is an image of a person or event taken directly from Christian Scripture or tradition, rendered in a specific manner, according to specific rules.

For almost two thousand years, Christians have created images that record the faith of those gathered around—and in the name of—Jesus of Nazareth and his followers. At times, there have been passionate, even violent controversies as to whether anyone can rightfully make images of Christ, his mother, the angels, or the saints. This discussion continues today. But, what is an image?

An image points to reality but never exhausts the reality to which it points. Even if we invoke our own mother's image, our mental picture will never truly capture her totality. Rather, our mental picture is colored by our experience and subsequent interpretation of that experience. Ultimately, our mental images are more about us than the realities to which they point. How much more difficult, then, it is to address the challenge of imaging God.

Scriptures tell us God is a rock, a shepherd, a fortress, a father, and so on. Does that mean that God is literally a rock, a shepherd, a fortress, a father? Or, are we saying that God is *like* these things for us? And, do these words about God exhaust the reality of who and what God is, in and of God's self? Certainly not. An image points to a reality, yet can never totally capture it.

Since the earliest days, Christians have struggled with the validity and propriety of rendering images of the Divine. The Eastern church has a more developed theology of images than the Western church as a result of the Iconoclastic ("Image Breakers") Controversies of the sixth through eighth centuries. During this period, due to some unfortunate political decisions, almost all the icons created by the early Christians were destroyed and iconographers were regularly maimed or imprisoned. The leaders of the Church finally had to step in to decide the role of images in the life of the Church.

Saint John of Damascus addressed those who opposed the making and use of images in Christian devotional practices. His opponents were influenced by Jewish and emerging Muslim adherents who abhorred the idea of creating images of God. John understood their concerns, since for them God had no physical manifestation. But, he argued, this was not the case for those who believe Jesus Christ is the incarnation and revelation of the Unseen God. For us Christians, God has a face. We can therefore represent God in and through God's first image or icon: Jesus. What we revere is not wood and pigment, but the reality to which that image points. These images can assist us in our spiritual journey. This position was adopted by the Seventh Ecumenical Council in 843 A.D.

Later, as a result of the Reformation, there was a resurgence in iconoclastic thought and practice. With little knowledge of or regard for earlier struggles, the value of Christian faith images once again came under violent attack. Until recently, followers of the Reformation tradition rejected any representations of the Divine in worship—while paradoxically immersing themselves in "The Word." After all, even the words of Scripture are but images.

Do icons of Jesus, Mary, the angels, or the saints actually reflect how they look? Perhaps, but this question completely misses the point. We live in a world filled with photographic images of reality—our reality, not necessarily God's. Often, our criteria for judging whether art is good or bad are based on how successfully it portrays how things actually look. As a result, we've become literal and somewhat narrow-minded about images, unable to let them speak to us of anything beyond immediate experience. But in the world of icons, our standard judgments do not apply.

Every attempt to define or express who and what God is will ultimately fail because we don't possess the capacity to capture the infinite with our limited human abilities. But we need to have

something to work with, and so we continue creating images. Unfortunately, somewhere along the way, we began thinking that the images *are* the realities to which they point. This, one of the greatest failings of fundamentalism in any of its forms, is idolatry.

Icons aren't meant to reflect our perceived reality. Indeed, they are purposefully rendered in a structured way that communicates that things are very different from God's perspective. Iconography, good iconography, strives to convey invisible reality in a visible form (see p. 20). The two areas where this is most evident is in the dematerialization of the figures and the use of inverse perspective.

The term "dematerialization" means rendering figures so that they're "transparent," almost lyrical. Think about how in a good piece of music, the excellence of the composition, instead of drawing attention to itself, takes us beyond musical notes and phrases to something greater than the sum of its parts. Similarly, good icons will not only present figures or scenes, but actually encourage us to transcend all our images and ultimately to find God.

Think, for a moment, about the stories of encounters with Jesus after the resurrection. In almost every instance, the people to whom he revealed himself didn't recognize the risen Christ. He was changed somehow, different than before his death on the cross. Jesus was already in the transfigured, glorified state, quite different than his friends had known him in life. Like Jesus in his glorified body, people portrayed in an icon are supposed to be—and look—different than they might have looked in real life. They are still human, but they are also transformed by the glory of God. That's what sets an icon apart from a photograph or a portrait. In icons, people are rendered in such a way as to emphasize their spiritual, rather than physical beauty.

In Russian icons, especially those of the Novgorod school in the fifteenth century, figures are elongated, their lines given an added, almost melodic quality. You will often notice a distortion of figures beyond what might be physically possible to communicate this sense of visual harmony. Consider, for example, the image of the Virgin of Vladimir. In this icon, the child's arm, which wraps around the Virgin's neck, is much longer than it would be in reality. Yet it does not seem awkward to the uncritical viewer. The distortion of reality, then, is a tool that points to something more important.

The way colors are built up can also add to the dematerialized quality of a figure within an icon. Translucent colors seem to melt away as light passes through the pigments, and is reflected off the white gesso ground of the panel, bouncing back toward the viewer.

So too, perspective is altered in the art of iconography. In our everyday lives, the further an object is from us, the smaller it appears to be. But in an icon, this perspective is reversed; things appear to get bigger as they move away from us. Instead of a vanishing point out there, somewhere on the horizon, we become the vanishing point. If you study icons that include architectural features, you will see that perspective has been altered to make the viewer the point at which everything vanishes. The spiritual implications of this are amazing.

In our limited understanding of the universe, we are the big thing, the center of reality. Everything that is not a part of us is smaller, less important somehow. But in God's reality, we are but a small speck, a vanishing point that is less than all that we take in. We are no longer the center of the universe—God and God's reality are. Our way of perceiving the universe can lull us into the illusion of self-importance. Icons contradict this view, challenging us to reconsider things we had previously taken for granted. It might well be that when the ancient icon painters began to render reality this way, it was due to their ignorance and naiveté. Nonetheless, they have provided us with an eloquent tool by which to challenge the generally accepted understanding of the universe with us at its center.

By employing classical concepts of idealized beauty and changes in perspective, icons speak to us of reality transformed and transfigured, both in and through God's presence. They speak of transcendence and mystery. As iconographers, we point to a reality we have never seen with our own eyes. In fact, all our images of God, heaven, the angels, and the saints, whether in poetry, prose, ritual, music, or icons, represent our limited attempts to speak of the unspeakable. It takes a great deal of trust and humility to embrace this fact, to move forward knowing that the task ahead is impossible. Nevertheless, we do move forward, using a common visual language so others will recognize and relate to the faith we are trying to communicate. Ultimately, then, icons are about prayer. They emanate from prayer and invite us to enter more deeply into prayer.

LITURGY AND DEVOTION

Throughout history, people have worshipped God in countless ways—there are even different styles of worship within individual churches. For the Christian, there's a distinction between liturgical practice and devotional (or popular) piety. Liturgy is the corporate action of and by the church—this type of worship is essential. Devotion, on the other hand, is more individual and optional. In liturgy, we act together as the Body of Christ (the Church) to offer praise and thanks to God in a variety of ways. Liturgy is not something that is done to us, or a spectacle that unfolds before us like theater. It is our action, done by all, on behalf of all, and for all. Each person has a specific role in that action. In liturgy, our prayer tends to be general and universal rather than specific. And, it is not just we who offer thanks and praise; we merely enter into the greater liturgy of heaven in which the entire universe worships God.

Recently I was traveling throughout Italy, Greece, and Turkey on a study tour of Byzantine art, which was quite a wonderful experience in itself. On the last night before returning home, I stayed in a hotel in the heart of Athens near the Acropolis. The balcony of the hotel overlooked a courtyard and faced a block of apartment buildings that also housed a ballet studio. As I stood there that evening, ballet students were rehearsing—stretching, moving to the music, and working on technique. Some, from my perspective, were flawless. Some seemed to struggle with the positions in a

clumsy sort of way. Quite a few spent a great deal of time trying to imitate others without much success. They seemed to be working on a dance to perform at some time in the future and by the looks of it, that would be quite a while. As the music began, the dancers ceased their individual regimen of exercises and preparations and focused solely on the dance. What a beautiful metaphor for the prayer of the Church and each of its members.

Each one of us has a routine for perfecting our skills in the spiritual life, and each one of us is at a different level of expertise. This is our personal piety, the devotional life in which we stretch our souls and seek to embrace God's will in our lives through prayer. Naturally, each individual must determine the practice routine best for specific circumstances, needs, and skill level. The goal is to bring our best to the great dance of God in the liturgy. In this dance, we continue to be individuals, but we are also part of something much greater than ourselves. We are part of the Church acting corporately as the Body of Christ. In this magnificent ballet of worship, there are no spectators among us because we all participate in the performance in some way, swept up into the action of the whole body. Thus, the dance of liturgy is the essential climax of all our practice, enhanced by our individual disciplines of prayer.

Iconography, like the Scriptures, can play a vital role in both the liturgical action and the devotions of individual believers by reminding us of God's ongoing presence and action in our world through Christ, the Theotokos, the angels, and the saints.

The icons that fill every nook and cranny of the walls of Eastern churches make the assembly keenly aware that they are surrounded by and embraced within the unseen cloud of witnesses of every place and time. They proclaim the truth that it is not just we who offer thanks and praise; but that we have entered into the greater liturgy of heaven, in which the entire universe worships God. Heaven is united to earth and the boundaries between the two seem to dissolve for a time.

The West, for many centuries, has been dominated by a highly rationalistic mindset that presumes to express and explain the nature of God through words. The East has only recently begun to express its understanding of God in those ways. For the most part, Eastern Christianity has always recognized that it can only say so much about God in finite, human ways before it must go silent before the mystery of the Infinite and Unspeakable. Instead of defining ultimate reality in theological concepts, the East has relied upon its artists, musicians, and poets to proclaim what can only be understood in the heart. My entire being resonates with their wisdom.

Icons proclaim God's reality in a visible way, which is why they're often referred to as windows into heaven. In our individual devotions, they help us to remember our connection with the divine by providing a focus for our wandering minds. We can relate to them in much the same way as we do a trusted friend or beloved companion, with an intimacy that mere words cannot communicate.

They comfort us in our struggles and challenge us when we fall into complacency. In our prayer with an icon, just as with the Scriptures, we can experience tangible reminders of the ways in which God is constantly telling us "I love you."

The icons in our churches and homes help us to remember that we are not alone as we enter into prayer, and that our action has implications far beyond what we see around us. Icons proclaim a reality that we cannot see but still believe exists. Whether we are aware of it or not, we dance with God.

ICONS AND GRACE

Over the centuries, icons have been described in many ways. They've been called hymns, sermons, prayers clothed with color, images of faith, pictorial theology, windows into heaven, and the gospels proclaimed in visual form. I invite you to consider that icons are tangible affirmations of the incarnation that offer us moments of sacramental encounter with the Source of all holiness.

Incarnational faith proclaims that God has entered into our reality by becoming a human person in Jesus of Nazareth. Because of this, all created things are hallowed by God's presence and possess the potential to speak to us of their Creator.

Christian faith hinges on a belief in the Incarnation—for us God has a human face. The Eternal God and Creator of the Universe became one of us in the person of Jesus of Nazareth to restore all things to their intended beauty. This event is a pivotal moment in salvation history, set within the process of God's ongoing incarnation in the hearts of women and men of every age who labor to bring God's Word to birth in their lives. Because of this, we believe that all of creation has a role in God's plan.

In *A Wounded Innocence: Sketches of a Theology of Art*,[2] Alejandro R. Garcia-Rivera discusses "the story of the Incarnation not only as God-with-us but also as heaven-with-us," confirming "the possibility of seeing the spiritually invisible through the materially visible." Thus, not only were humans blessed by Jesus as he walked our dusty roads, looked up at the stars, and drank deeply of the beauty that life offers. Everything in existence was sanctified by the miracle of his presence among us. Christians see the fingerprints of their Maker in all of creation. This is why we use the things of the earth to represent, express, and deepen our faith: water, oil, bread, wine, fire, incense, and even icons. We call these things sacraments.

A sacramental encounter happens when we experience God in or through something tangible, like a person or a thing. Christians use many things in this respect, things like bread, wine, water, fire, oil, and so on, to express and experience God's presence.

Our tradition proclaims that God uses the stuff of the universe to reach out to us, bridging the gap between our reality and the Divine. But the seven sacraments, the official grace-filled rituals of the Church, aren't the only outward signs through which we can encounter God. In fact, there have been a variety of "sacraments" recognized by Christians over the centuries—the official number of seven sacraments hasn't always been so firmly fixed. Perhaps Saint Augustine, who died in the fifth century, said it best. He wrote that a sacrament is "a visible sign of invisible grace." These signs, these sacraments, address "the whole person, body and soul," and not just our intellects or emotions or spirits.

Like the early Christians, Eastern believers often refer to the sacraments as "mysteries." Indeed that is what they are. It's a mystery that God continually reaches out to us, and in so many ways. Reflect for just a few moments, and you'll realize that it's simply not possible to create an exhaustive list of how, where, and when we may encounter God. Our God is full of surprises and everything in God's creation has the potential to be sacramental in some way.

For the Christian, Jesus Christ is the primary sacrament of God. He is the fullest sign of God's invisible grace in our midst. In Jesus, we see and experience the God we cannot see or experience without some sort of material mediation. All other sacraments exist as a result of the Incarnation of Christ. The number of ways to encounter grace is limitless, but we experience God most clearly in one another. Our brothers and sisters from the Eastern churches, like all of us in the Judeo-Christian tradition, believe that human beings are created in the image of God. For the Eastern Christian, this image remains within each of us, its brightness clouded by layers of tarnish caused by sin. We are all icons of God to some extent. If we could only see through whatever obscures that image, we would encounter our God in every person we meet.

Every now and then we meet human beings so transparent that we experience God when we encounter them. We call these people saints, living sacraments, and we remember them specifically because they have invited us to remember God in concrete and consistent ways. It's rare to meet such people in person, and those of us who have can consider ourselves blessed. The saints are people in whom the layers of grime have been cleared away enough to allow us to actually see God in their lives.

Eastern Christians also believe that when we look upon the icons of the saints we are somehow in the saints' presence in an intimate way. We can experience God shining brightly in and through them. These images are not simply pictures of what these people looked like or portraits that communicate something about their personalities, although icons incorporate aspects of both of these. Much more, icons present the saints as people transfigured and transformed by grace. They show us what people look like when God gets through with them.

Although icons aren't included among the official sacraments, they offer believers the possibility of sacramental encounter. Like all sacraments, icons proclaim and celebrate the incarnation ("God-with-us" and "heaven-with-us"), finding their origin in Jesus Christ. They are pictures of grace, inviting us to experience God's abiding presence in our prayer before them.

ICONS AND PRAYER

To speak about the use of icons in prayer—as well as icon painting as prayer—we need to begin by noting that there's a very real difference between saying prayers and praying. Obviously, these two things can, and often do, overlap. Still, we've all had the experience of saying prayers, then recognizing afterward that we haven't actually prayed. On the other hand, haven't we all had prayerful experiences that haven't involved consciously verbalized prayers?

Prayer opens us to the presence and action of God in our lives. Some spiritual leaders teach that whatever takes us beyond the self places us in the presence of God. One profound contribution of Eastern Christianity is the recognition that we can pray, or at least be moved to prayer, through our senses. Things that engage our senses can be sacramental—often without our being aware if it.

There are many ways to look at icons and a wide variety of motivations for painting them. If yours is a desire to pray, the following practices may help you to touch the silence that can be found in the presence of the sacred.

PRAYING WITH ICONS

Icons aren't just found in churches. Throughout the Eastern Christian world you can commonly see these images of faith in believers' homes, at roadside shrines, in the workplace, and wherever life happens. Their presence is a sign of blessing and a plea for heavenly protection. In the home, family prayers are offered before the icons enshrined on the home altar, also called the Beautiful Corner.

You won't be surprised to learn that my own home is filled with icons—not enough to make it look like a church, but they have a definite presence in my living space. A large icon of the Holy Face hangs in the living room and before it burns the flame of a hanging lamp. The Holy Trinity watches over the kitchen, a wall of Christ icons graces the hallway, and another is in the guest room. The icon corner is in my bedroom and isn't actually in a corner but is the place where I go to pray. It has a small, low table covered with a beautiful cloth and on it sits a small wooden box containing slips of paper with the names of people I want to remember before God. There's also a book of the Psalms, a votive candle, and a bowl for incense. On the wall above the table hang icons of my heroes in faith: Saint Benedict, Saint Andrei Rublev the Iconographer, and Thomas Merton. The icons are adorned with my great grandfather's rosary, some sprigs of olive from Taize and Assisi, and a Jesus prayer rope from Greece. Late at night it is not uncommon to find me sitting before them with my dog, Tristan, snoozing in my lap. He gets a bit of sleep while I seek guidance and the silence of God in the midst of my hectic life. It's the heart of my home.

The Beautiful Corner is often placed prominently in an eastern corner, the direction of the rising sun—from which Christ will one day return in glory. Traditionally, icons were lit by the candles

or oil lamps that burned before them at all times, so that even during the darkest night, their gentle presence was known.

Icons can be a powerful link and reminder of the ongoing presence of God and the holy ones in our homes. Consider your favorite prayer spot and how it would be blessed by the addition of an icon. As far as I know, there aren't any rules for creating a prayer corner, so you can experiment a bit and find what works best for you. The point is prayer, so create a place that is free of distraction, one where your attention will not be drawn away to the telephone, the television, the computer, the dog, or the kids. Then, go there and offer your prayers. When you have finished with what you have to say, take some time to listen with your heart and with your eyes. You will be amazed at the many ways the icons will speak to you of the abiding goodness of God.

When approaching an icon for prayer, it may be helpful to begin by placing your concerns and problems in God's hands during your prayer time, allowing God to hold whatever might distract you. Ask God to speak to your heart, perhaps not with words, but speak nonetheless to the depths of your being.

Gazing

One way to pray with an icon is simply to look at it. Here, I'm referring to a particular kind of "looking."

In our culture, we frequently look but don't actually see. We give things the "once over," scanning to obtain information. We view what we're looking at as an object, something to download, sort, define, use and, eventually, delete from our files. Icons require—and deserve—a different kind of "looking."

When you come to look at an icon, give yourself entirely to the experience. Let your gaze rest on the icon until you see not just what you think you see (or want to see). Instead, look deep into the image. Gaze until you can see it, not just with eyes or intellect, but with your soul and heart as well. Let yourself become completely absorbed in this sacred encounter.

You can develop this skill by spending a few moments each day, for several days or even weeks, gazing at a specific icon. Simply be willing to show up, spend the time, and sit.

For me, the act of painting can itself be an act of prayer if I give myself over to that experience so completely that I forget myself, losing myself in the act of creating. Often, while painting, I'll ask for God's help and presence as I work. That doesn't mean that God was absent before I made my request, but that I might not have been very present to God.

Give yourself to the experience as fully as you are able, letting go of everything else as much as you can. Don't let expectations sabotage your experience. Simply be with the image. Look and look

until you truly see. Listen with your eyes. There are no rules for doing this. Be gentle with yourself and your prayer. One of the most notable aspects of Eastern iconography is the profound stillness of the figures and scenes. This stillness can draw us in, transmitting its sense of calm and serenity to our hearts.

Breathing

Adding an awareness of breath can be a powerful addition to this practice. Notice the inward and outward movement of air in your body. Try linking this to the Jesus Prayer:

> *Breathing in:Lord Jesus Christ,*
> *Breathing out:Son of God,*
> *Breathing in:have mercy on me*
> *Breathing out:a sinner.*

You can simplify this prayer even further:

> *Breathing in:Jesus,*
> *Breathing out:mercy.*

In either case, the point is not the words, but the rhythm that clears away the internal noise. Allow the prayer to become as natural as your breathing and as deep as your own heartbeat. The Jesus Prayer is a wonderful aid to the act of remembering how we are always and everywhere in God's presence. Saint Paul tells us to "pray at all times." This means we must strive to *be prayer*, not just to say prayers.

Icons speak in silence and they speak of silence, the great silence of God. To those of us from the West, this may seem strange and paradoxical. Eastern Christians have an entire spirituality of silence that has played a significant role in their approach to iconography. Known as "Hesychasm," this refers to a state of spiritual repose or quiet attained through the grace of God, solitude, and contemplative prayer. We from the West may insist that our God is not mute and never silent, but the Hesychast understands that the silence of God reveals more than all human knowledge combined. The Hesychast insists there's a huge difference between knowing *about* God and knowing God. To know God, we must quiet the endless newsreel of thoughts, perceptions, opinions, and reactions that fills our minds and hearts, and then abide in the silence. This is done with the aid of the Jesus Prayer, an ancient mantra that can still the mind and open the heart to the silence of God. Although not all iconographers were Hesychasts, the best iconographers usually were, because they painted what they knew most intimately.

PAINTING AND PRAYER

You can use the same prayer process as you paint an icon: Give your concerns to God, still yourself by breathing consciously and/or using the Jesus Prayer, and then begin. You can expect many thoughts to pass through your consciousness as you work; just allow them to become part of your prayer.

Remember, too, that there are many rules and regulations, skills and techniques to learn as you begin to explore iconography. Until you become comfortable with these, your attention will be divided. Keep working at it and try not to expect too much too soon. As your abilities develop, your self-consciousness will diminish and your experience of prayer will increase. All you really need to do is to learn how to work in a way that carries you toward God.

> I have made thousands of people and situations part of the icons I've painted by imagining them as individual brush strokes, painting them into the icon. At other times, I've been so involved in the process of painting that I've not been aware of anything else and been surprised to discover that hours had passed.
>
> These are experiences of timelessness, of the eternal now. I've come to understand these as experiences of the Kingdom of God. Obviously, this experience of the sacred is not limited to iconographers, but iconography can be one avenue to the experience.

Fasting

You may have heard about the tradition of fasting while painting an icon. Indeed, my first teacher recommended abstinence from meat and alcohol while working. Over the years, I've developed an approach that might be useful for anyone wishing to paint in a way that reflects an older, scriptural understanding of prayer and fasting.

Fasting can take on many meanings; some are more helpful than others. Often, fasting involves depriving ourselves of something, an act of sacrifice pleasing to God. The problem with this approach is that it can turn into a form of bargaining with God.

Scripture is filled with references to fasting, but one of the clearest and most challenging passages comes from the Prophet Isaiah:

> *Is this the manner of fasting I wish . . . that a person*
> *bow their head like a reed, and lie in sackcloth and*
> *ashes? Do you call this a fast, a day acceptable to [your*
> *God]? This, rather, is the fasting that I wish: releasing*
> *those bound unjustly, untying the thongs of the yoke; set-*
> *ting free the oppressed, breaking every yoke; sharing your*
> *bread with the hungry, sheltering the oppressed and the*

*homeless; clothing the naked when you see them, and not
turning your back on your own. Then your light shall
break forth like the dawn. . . Then you shall call, and
[your God] will answer, you shall cry for help, and
[God] will say: Here I am!*

Isaiah 58: 5–9 NAB

Fasting from self-centered and self-serving ideas and actions is a far greater and more difficult sacrifice than simply depriving ourselves of small luxuries. If you fast, do so to become more just, more loving, more of what God envisions for us. Become your prayer and open yourself to compassion. There is no better way to make you ready to render the silence of God and the compassion of God as these things radiate through the faces of God's holy ones.

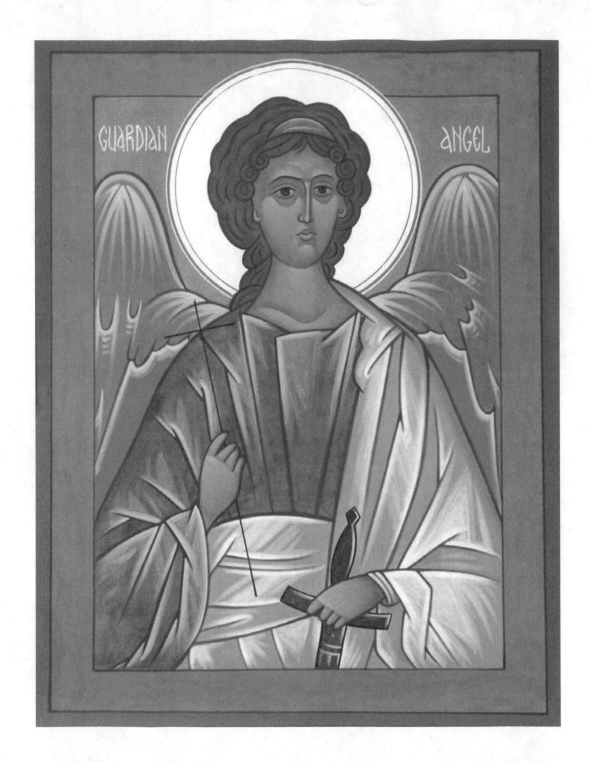

The Basic Icon Toolkit

Here's a list of the basic—and essential—materials and equipment you'll need to paint icons. Over time, your personal list will vary as you deepen your own brush with God. To get started:

RESOURCES
 Books
 Prints
 Icon calendars

ART SUPPLIES
 Brush cleaner/shampoo
 Erasers (kneaded and "Pink Pearl")
 Glazing medium (Jo Sonja's Magic Mix or Golden's Glazing Medium)
 Gold leaf (Italian patent gold)
 Gold size (water-based)
 Masking or painter's tape
 Paints (Jo Sonja and/or Golden Acrylics recommended):
 Bright red (napthol red light)
 Deep red (Indian red or violet/purple oxide)
 Brick red (red earth, Venetian red)
 Warm yellow (ochre/yellow earth/yellow oxide)
 Turner's yellow (whitish yellow)
 Green (green oxide)
 Deep blue (storm or cobalt)
 Burnt sienna (a red-brown)
 Raw umber
 Black
 White (titanium or warm white)
 Panels (See instructions for preparing panels on page 16; also see Appendix B on page 66 for panel makers' contact information.)
 Pencils (fine point)
 Polyurethane (satin finish, oil-based)

ART EQUIPMENT
Brushes (acrylic, long hair):
 10/0 liner
 1 round
 3 round
 6 round
 10 round

Brushes (sponge): 2"
Color wheel
Compass
Cork-backed ruler
Halo template (concentric circles plotted onto Mylar)
Pencil sharpener
Plates for mixing paints (plastic or styrofoam)
Rags or paper towels
Ruling pen
Ruling pen with compass
Tack cloth
Water containers (plastic yogurt cups work well)

STATIONERY SUPPLIES
Carbon paper (not too waxy). You can create your own using conté crayon and tracing paper
Tracing paper

MISCELLANEOUS
Film canisters for paint mix storage (get clear ones with good lids)
Natural fiber cotton balls

PREPARING PANELS
When you have the right tools—and patience—the wood panels used for icons are relatively simple to make:

1) Begin with cabinet-quality birch plywood cut to the proper dimensions.[3] If you're doing the cutting, use a circular saw with more, rather than fewer, teeth to create a smoother cut.

2) Next, fill gaps or holes in the plywood with putty and let it dry completely. Do not expect gesso to cover any cutting flaws.

3) Thoroughly sand the edges or sides of the panel.

4) Gather various sizes of sponge brushes and grades of sand paper. You'll be using a range of medium to very fine grain sand papers with a wood block or a palm sander.

5) Now, apply a layer of gesso, brushing it on in several directions, perhaps using X-shaped strokes. Let this coat dry completely, then sand well.

6) After this coat is completed, you may wish to apply cloth to the panel.[4] Dip cotton sheeting into the gesso and apply it to the panel, smoothing it on with your hands to remove air bubbles. *Do not wrap the cloth around the sides of the panel.* When completely dry, use a razor blade to cut away excess cloth from the panel. Sand.

7) Repeat the layers of gesso up to ten times. Each time, make your brush strokes in various directions to avoid ridges in the gesso. Sand smooth between each layer. You may want to "wet sand" (allow the gesso to dry and then sand with water)the last time, as it makes the board very smooth, or simply use a brown paper bag to do the final sanding. Its fibers are rough enough to do the job, yet they are not nearly as harsh as steel wool.

8) Let the panel sit for a few days to cure.

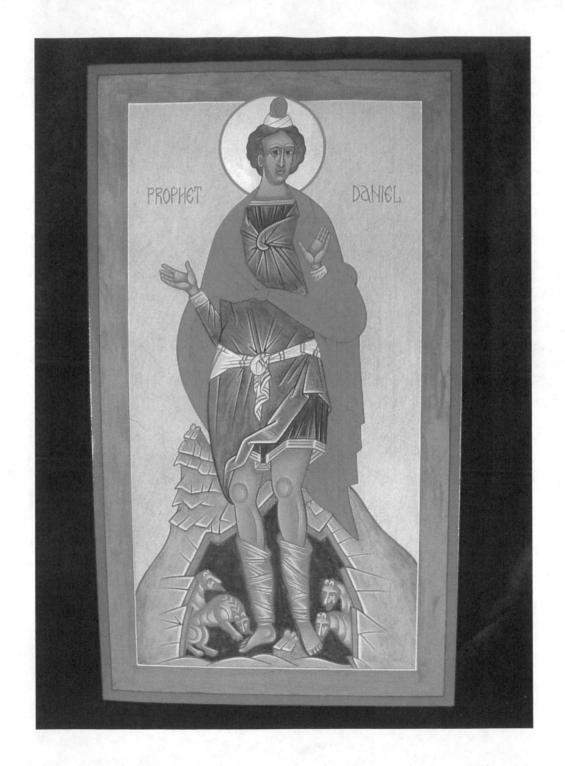

— CHAPTER THREE —
The Icon Painting Process

PROCESS OVERVIEW

In any field, beginners tend to mistake details for the heart of the matter, and this holds true in the art of iconography. Eventually, you'll discover that less really *is* more. You'll discover how one well-painted line—expressive and clear—is better than any amount of unnecessary detail.

I invite you to watch the whole process of painting an icon with great curiosity and care. Let go of your human tendency to judge yourself, your progress, your competency. You can expect this sacred art to infuse your being over time and its richness will become a part of you. This happens much in the way that hot water becomes tea only after leaves have steeped in it—slowly, ever so slowly.

As you progress, this icon-painting process will make more sense. Your skills will mature, as will your understanding of what you're striving to create. You'll discover that the method of creating an icon is really quite simple, although you could easily spend a lifetime trying to master it. But once you understand the process, you'll be able to create any icon you are called upon to paint by breaking it down into components.

For a very long time, icons were dismissed and discounted in the world of fine arts because few people understood these murky panel paintings. Due to the materials used to produce older icons, the images had become darkened over time by smoke, dust, and soot. Recent discoveries by those engaged in art restoration have made it possible for us to behold the original beauty of ancient icons. This provides a wonderful metaphor for the Eastern approach to Christian spirituality, that of *Theosis*: God became human so that we might once again become like God.

Unlike the West, with its focus on atonement and original sin, the East has always professed a fundamental belief that the material world is good because it is created by God. We are good because we are created in the image and likeness of God. That original beauty has been obscured but not obliterated by the ravages of fear, sin, and death. Like ancient icons, all we need is skillful care and a good cleaning. This theology of beauty, and its basic optimism, underlies the Eastern approach to salvation history. Humanity plays a vital role in God's plan. We are called to participate in the redemption of creation by actively cooperating with God in the restoration process. Ultimately, this beauty—God's beauty—will save the world.

Start with a Good Drawing

A good drawing is the single most important part of an icon. Good icons never come from bad drawings, and you can't count on anything refining itself during the painting process. You simply must begin with a well thought out and skillfully executed drawing. But these drawings are not based on the artist's preference or sketched from imagination. It would be more accurate to note that they're "constructed" from one or more prototypes, along with a strong understanding of the sacred geometry used by previous iconographers. Because of this, many teachers insist novice icon painters copy the masters for a long time before attempting to create their own drawings. One good source for information about constructing an icon sketch is Father Egon Sendler's book *The Icon: Image of the Invisible.*[5] Although the text is somewhat dense and challenging to understand, it's well worth continued study.

Practice drawing with either a pencil or brush. Copy the masters until you know the classical images as well as you know the faces of your friends and family. Refine and rethink your sketches. With practice, you'll be able to make your hand draw what your eyes see and your mind envisions. The better your drawing skills become the better—more harmonious and graceful—your icons will look.

Unlike most of the art that surrounds us, an icon is not meant to communicate the way things look to us, but how they look in God's eyes. Figures and scenes are rendered to emphasize spiritual, rather than natural, qualities. This transfiguration of conventional form is conveyed by the use of dematerialization and inverse perspective in icons.

A good icon presents a figure or scene in a way that invites us into that deep place where the image melts into God. Icons depict those who have been transfigured by the glory of God. This is what sets an icon apart from a photograph or a portrait. In an icon, a person is rendered in such a way as to emphasize spiritual, rather than physical beauty. The figures are meant to point to recognizable human figures, but with more gracefulness and idealized beauty. The distortion of reality is a tool that points to something more important.[6]

Create a Positioning Grid

Everything in an icon is related in some way to every other part of the icon. To see this most clearly, I have been taught to lay a sheet of tracing paper over a print of an old icon. Next, draw lines onto the tracing paper to divide the image in half vertically and horizontally; then draw diagonal lines from corner to corner. Now, do the same with the smaller rectangles you created by dividing the image. Notice how the lines of the figure correspond to the lines you've drawn—where the arms fall, the curve of the body, etc. This will give you a glimpse of how icons are supposed to be designed.

Icon panels are usually constructed according to a 3:4 ratio (for example: 9"x12", 12"x16", 15"x20", etc.) for busts or half-length single figures that show a figure to the waist. For full-length, standing individual figures, I often use a 1.5:4 ratio (for example: 3"x8", 4.5"x12", 6"x16"). Using these ratios is especially helpful if icons of standing figures are placed near single bust figure icons.

Create Borders

Most likely, the idea of putting a border around the image is a holdover from the time when most icons were painted on solid wooden panels with raised borders. The hollowed-out area in the center allowed the painter to support his arm on a board anchored on the raised borders of the panel so that his hand would never touch the painting surface, thus, preventing skin oils from affecting the egg tempera medium.

Today, many icons are painted on flat panels of high-quality plywood and, unless you work in egg tempera, these preventative measures are no longer necessary. Still, iconographers continue to paint borders that recall the raised ones on older panels.[7]

As you study older icon prototypes, you will notice that there are three options:

1) Use the same width for each side of the border.
2) Make the top and bottom border one width, and the sides another.
3) Make the top and sides the same width, and the bottom a bit wider.

Border dimensions depend on the size of the panel and nature of the image. I often prefer having some element of the image—the halo, a scroll, or an article of clothing—break into the border area. Not only does this add visual interest, but it also serves to remind us that holy figures are not confined by linear limitations.

I suggest taking the path of least resistance (and thinking) during your first ventures into iconography, saving work that is more complex for later. Just make your border 1" or 1¼" wide on panels up to about 2 feet tall; after that you'll have to adjust. On very small panels, you'll want to reduce the width of the border. After deciding on a width, draw these borders onto the panel with a pencil and ruler.

Now pencil a vertical line down the center of the panel so you can balance the single bust or half-length figure. (This also applies to icons of the Mother and Child.) If there's more than one figure (especially standing figures), you may divide the panel into thirds or quarters so that all figures are evenly spaced.

Note: Rather than drawing and redrawing the sketch, simply enlarge or reduce it on a photocopier to create the appropriate size image for the panel. Make sure the image is neither too large nor too small for the space within the borders and that the halo, when added, won't exceed the size of the panel.

Transfer the Drawing

Once you have a good drawing and have traced it, you'll need to transfer it onto the wood panel onto which you've penciled in borders and dividing lines. These transferred drawing lines will guide the entire painting process.

21

POSITION THE HALO

Halos are usually about three nose-lengths in radius, but don't make it too big or the icon will look top heavy. The center point is plotted by using a "halo maker." This is simply a sheet of transparent/translucent acetate or Mylar upon which concentric circles are plotted about ¼" apart (see appendix D on page 68 for halo template).

Lay the halo maker on the drawing and move it around until you find that the outline of the head roughly conforms to one of the circles. This will help you find the center of the halo, which will fall somewhere near the eyes in full-view faces and between the ear and the eye on ¾ views. Once you determine the center point of the halo, place a small "X" on that spot on your drawing.

Using a dimension that's half the width of the board, measure down the vertical center line this amount and make a pencil mark. This is where you'll place the center of the halo so that it's balanced relative to the borders. You may also place this point slightly higher on the center line, so the top of the halo overlaps the border, giving the top a rounded appearance.

POSITION THE DRAWING

Once you've determined where the image will be placed, tape the traced drawing onto the panel, creating a masking tape hinge along one edge. This will allow you to lift the drawing to check your progress as you transfer the image onto the panel.

TRANSFER THE DRAWING

Transfer your drawing by placing a piece of non-waxy carbon paper directly onto the panel and under the drawing. This time, as you draw the image, it will transfer onto the panel. Check to see that you haven't missed any lines before removing the taped drawing, making sure that you've also transferred the center point of the halo. Once you're confident that all lines have been transferred, remove the drawing. Draw the halo with a compass.

PAINT THE TRANSFERRED LINES

Using a fine liner brush (10/0) and any dark color, paint over the lines of your drawing. Do not paint the "X," the halo lines, or the border lines. Once these lines have dried, erase the pencil lines and the carbon paper smudges.

Paint the Undercoat

The final preparatory step involves applying several layers of translucent color (yellow ochre, yellow oxide, yellow earth, or a red-orange) to the panel's surface, using short irregular brush strokes. Avoid the old house painting technique of doing only vertical or horizontal lines, since these will leave you with stripes where the paint is thickest. I suggest that your brush strokes resemble "Xs."

You may apply two to six layers of this color, depending on how watery your paint is and how deep you'd like the undercoat. This process gives subsequent translucent layers of color more complexity and a golden "candle glow."

Fill in the Base Colors

Next, fill in the base colors using quick, short brushstrokes. Stroke the paint on in a variety of directions. This will even out the color as layers of pigment are built up. In the Russian style, base colors are applied in translucent layers. You'll want to be able to see the lines of your drawing through the layers of paint. Except for skin tones, which are a bit more opaque, colors are built up with semi-transparent layers onto the panel surface. In the Greek style, base colors are generally opaque.

Limit the number of colors you use in any given icon, finding creative ways to mix pigments to fill out the image. I've seen masterful works by Russian iconographers created with no more than five or six colors. A limited palette of well-chosen colors will create a richer icon, as will building up layers of paint in contrasting colors, such as putting a layer of orange underneath something that will eventually be blue.

Create a Border Color That Compliments the Image

If you're undecided about a good border color, try using the basic flesh tone (sankir) to create a sense of harmony with other colors in the image. In any event you'll want to avoid dark colors, since these will create a picture-frame look.

Shadow and Highlight the Base Colors

After the base colors are laid in, they're highlighted with a lighter shade of that color, except when a "double reflection" is used. The double reflection technique uses a complementary color for highlighting (see pages 35–36). All highlights should be done in moderation and, in the Russian style, are sometimes completely omitted. This can be seen most clearly on the deep red garments of the Mother of God.

Since the figure itself is considered the source of light, there aren't any logical physical rules for delineating light sources. We simply try to give the impression of a body under the cloth, creating a bit of volume. In general, base colors are the shadow tones, although shadows are used sparingly in the Russian style.

Re-paint the Lines of the Original Drawing

Once highlighting is completed, the figure and background elements are outlined and the other lines of the original drawing are reinstated. If you're working in the Russian style, you can use some combination of red earth (brick red) and black—more red earth for lighter base colors, more black for

darker ones. Exceptions are white and skin tones. Outline white with an orange color created by mixing red earth with yellow ochre. Outline skin tones with burnt sienna (reddish brown) or a raspberry red created by mixing bright red with a bit of black. If you're working in the Greek style, simply use a darker shade of the base color of any given area.

Apply Gold Leaf

Gold leaf is used to create icon halos, backgrounds, and highlighting on some garments. The application process is actually much simpler than you may suspect, although working with gold does require a heightened level of skill (see pages 39, 40 for technique).

Gold leaf usually comes in one of three forms: loose-leaf, patent, and assist. In loose-leaf books, gold leaves are placed between layers of tissue. They're lifted with a statically-charged camel hair brush.[8] This must be done in a room where there is no air movement, to prevent the leaf from flying away on the air current. Patent gold also comes in books of tissue paper, but these leaves have already been statically attached to the sheets of tissue paper. Although you must still work in an environment with minimal airflow, you're in much less danger of losing control of the gold. Assist is gold leaf mixed with gum arabic or honey and can be used much like ordinary paint.

In any case, *never* touch gold leaf with anything other than the tissue it comes with, a natural fiber cotton ball, or a clean soft bristle brush reserved only for gold work. The gold is thinner than a butterfly wing; even touching it with your fingers will cause it to disintegrate.

Glue

To get the gold to stick to the surface of the panel, you must first apply some kind of glue (also known as size or bole), which can be either be oil- or water-based.

Oil sizes are self-leveling as they dry. This creates a nice smooth surface onto which you can place the gold. Unfortunately, they also tend to flow beyond the intended gilding area and clean up requires paint thinner or other oil-based products.

Water-based gold size dries very quickly and, if applied in a thin, even, (but not overly diluted) coat, also provides a good base for the gold. If you tint the water-based size with some red paint, you'll be better able to determine whether you have missed any spots. This also helps to warm the color gold from underneath; the leaves are so thin that they are almost translucent.

If you want to try an older method, get some bole (that is, clay base) for the gold. This is applied at the beginning of the painting rather than at the end, as with other sizes. Bole is brushed on like paint, and then sanded with extremely fine sand paper. The gold is applied by breathing a hot, moist breath onto the bole, which opens up the pores of the bole. Apply the gold quickly, before they close up again. After the gold leaf is applied, use an agate stylus to burnish (or polish) the gold.

Finally, you can use garlic juice, which is very sticky, to apply the gold. If you want to go this route, wait until winter—heat makes garlic juice become rather pungent.

Time for Detail Work

After you've completed all of these steps, go back and refine anything that needs a bit more work. I call this "futzing." It's a Yiddish term for fixing what really isn't broken—you could also call it "fussing." Add decorative details at this point (for example, pinstripes, flowers, outline of halo, lettering, jewelry, spears, sandals), but avoid the use of unnecessary decoration and gimmicky techniques, which will only cheapen the look of your icon. Details should add interest or invite the eye to one part of the icon, not demonstrate your technical prowess.

Add an Outer Border

I usually add a quarter-inch border around the outside edge. It's painted the same color as the sides of the panel—usually some shade of red. This outer border can be wider on larger panels. Sometimes the inner border is completely omitted, leaving only the red outer border to allow a greater area for the image.

Varnish Your Icon

When it's time to varnish your icon, you have a wide variety of options. You can find any number of protective finishes at any hardware store: oil-based, water-based; varnishes, polyurethanes; flat, satin, semi-gloss, gloss; spray-on finishes and ones that require brush application. For indoor icons, I recommend applying *oil-based satin polyurethane* with a foam brush. Also:

After painting icons for over thirty years, I finally began to truly understand the genius of Andrei Rublev, noted for his wonderfully simple icon of the Holy Trinity. In this famous image, Rublev eliminates many details that have traditionally been associated with this icon (e.g., Sarah and Abraham bringing food to the table, servants preparing the feast). In his rendering, Rublev captures essence by eliminating elements that would only obscure our understanding of who is seated at the table. His graceful lines and masterful highlighting negates the need for excessive ornamentation.

- Avoid "fast drying" varieties.
- If you decide to use a water-based finish, remember to seal the gold leaf halo (where it touches the paint) to prevent the halo lines from floating away. The water base of these types of finishes tends to loosen the paint that touches metal leaf. It's not pretty.
- Be careful about using a spray. It basically "spits" finish onto the surface, making it almost impossible to get a smooth finish.
- If you use a gloss finish, expect glare from the faintest light source.
- Use a foam brush because the hairs of an ordinary brush may produce ridges in the finish. Clean-up is also a headache.
- If you want to enshrine the icon outdoors, use a marine-quality product and do not display the icon in direct sunlight.
- Do *not* attempt to "antique" your icons.

Sign Your Icon

Icons are not signed, at least not on the surface of the panel. Iconographers are supposed to be anonymous. But if you wish, you may sign it on the back in the following manner:

<div align="center">

†

By the hand of
Your name here
Date

</div>

Have Your Icon Blessed!

See Appendix F: A Prayer for the Blessing of Icons.

About Color

Let's start with a bit of color theory. All colors within our visual range are made up of the primary colors: red, yellow, and blue. Every other color can be mixed from these primary colors. Artists also refer to secondary colors: orange, green, and purple. These, along with the primary colors, form the color wheel—one color melting into the next in an endless circle.

On the color wheel, yellow is added to red until it becomes orange; keep adding yellow to orange and eventually (gallons later) you'll end up with pure yellow. Yellow becomes green by adding blue. Blue becomes purple by adding red, and so on.

The hue (intensity) of a color can be subdued by mixing in some of its opposite color on the color wheel. Add a bit of orange to blue, or red to green, or yellow to purple, and notice how the brilliant, jewel-like edge of the color is removed. You can also mix browns and grays by combining these complementary colors. White and black stand apart from the basic colors; you can use them to lighten and darken colors.

I invite you to experiment until you feel comfortable mixing the colors you need, instead of buying countless tubes of very specific colors. In fact, learning how to do this will actually give you more control over the painting process. Not only does every pigment manufacturer name its own colors, but even colors with the same name can vary greatly from company to company. Add to this the fact that the old icon manuals do not distinguish colors beyond light and dark (for example, light blue/dark blue), and you can easily understand why specifying icon colors in premixed acrylic paints is difficult, if not impossible.

Before manufactured pigments were available, painters relied on a variety of earths (dirt), minerals, rocks, vegetable dyes, and other organic materials that were at their disposal. Today, you can still purchase these natural, dry pigments from specialized companies. Even simple yellow ochre is available in a spectrum of subtle and not so subtle contrasts.

Whether you use dry or premixed pigments, you'll soon notice how each color has its own unique personality. This is due to the materials from which the pigment is made. Some colors tend to be gummy, while others flow like ink. Some are quite opaque and others are transparent. The weight of some pigments varies so that their component parts will settle and separate if too much water is added. Only practice will enable you to know how certain colors will perform alone or react with one another.

After studying icons more closely, you'll note how certain colors don't appear in many of the ancient images. This is probably because they weren't widely available until recently. Until the twentieth century, most icons didn't employ jewel tones—brilliant, raw colors (red and blue being exceptions). Today's technologies allow us to create contemporary icons with more brilliant, pure colors and with a far wider palatte than our ancestors.

STOCKING THE BASICS

With these pigments, you should be able to mix any color. Be patient! The ability to see color components takes practice. Here's a basic set of colors that you can use to create any icon you're called to paint*:

Brilliant Red (Napthol Red Light*)
Deep Red (Indian Red Oxide* or Violet Oxide)
Red Earth* or Venetian Red (Brick Red)
Yellow Ochre, Yellow Earth, or Yellow Oxide* (Golden's Yellow Ochre for skin tones.)
Turner's Yellow* (Whitish yellow)
Brilliant Green (Green Oxide*)
Deep Green (Forest Green or Pine Green*)
Deep Blue (Cobalt Blue, Navy Blue, or Storm Blue*)
Brown and/or Burnt Sienna* (Reddish brown)
White (Titanium White* or Zinc White)
Black (Carbon Black* or Bone Black)
Raw Umber* (for mixing transparent shadow colors)

GLAZING MEDIUMS

Throughout the painting process, glazing medium can help you "stretch" your pigment, increase the translucency of pigments, and fortify the acrylic binder, which might be compromised by adding significant amounts of water to the paint. Every time you add a bit of water to acrylic paint, you weaken the acrylic binder which holds the paint together, in a manner of speaking. Adding some sort of

* Jo Sonja color name

medium will counteract this without adding more pigment or opacity. (In egg tempera, these would be the equivalent of adding more egg emulsion to the paint.) There are many good options available. Golden Acrylics makes an excellent glazing medium and Jo Sonja offers what they call "Magic Mixture," a combination of mediums that increases the flow while adding translucency.

To use a glazing medium, simply mix paint to the desired consistency with water and then add a drop or two of the medium (adding a bit more water if you desire). Practice and experimentation will enable you to master the use of glazing medium so you can achieve the desired results.

THE CANON OF COLOR

As iconographers, we communicate the Gospel in color and line. So it's vitally important to know about color and its symbolic, spiritual meanings in icons.

The colors used for garments and occasionally the backgrounds in icons are clearly defined—it's a canon of color. Even colors that seem somewhat general always speak to the saint's life. For example, ascetics and monastics are clothed in earth tones (usually dark) that refer to voluntary poverty and self-denial. Martyrs wear bright red cloaks or the background for their icons is rendered in the same bright red to signify blood shed as a witness to faith. Archangels and apostles all have specific garment colors to make them easily recognizable.

Images of Christ and the Theotokos (Mother of God) provide the clearest color reference to their roles in salvation history. In iconography, deep cherry red refers to all that is human and earthly, while deep blue speaks of all that is transcendent and of God. Christ, except in icons of him as a child and after his resurrection, always wears a deep red inner garment and a deep blue outer garment because his humanity has been wrapped in divinity.

Conversely, Mary always wears a deep red outer garment with a blue inner garment. In the iconographic language of color, this color configuration tells us about the one who carried divinity within her humanity. Knowing the Byzantine meaning of the colors used for rendering a figure in iconography can tell you a great deal about their role in the unfolding of God's reign.

Red: Everything of the earth, humanity, blood, passion, fire
Bright red: Martyrdom/witness to the faith
Deep reds, closer to purple: Royalty
Earthy yellow ochre/oxides/gold leaf: The uncreated light of God's presence
Green: Life, hope, wisdom
Blue: Transcendence, mystery, all that is of God
Brown: Poverty, monastic and ascetic life
Black: Sin, death, solitude, ignorance
White: Glory, transfiguration

OVERALL COLOR SCHEMES FOR BACKGROUNDS AND BORDERS

There are two options for backgrounds and borders, either of which creates a different overall look for the icon. Use a monochromatic (different shades of the same or similar colors) scheme when you want a more subdued and subtle look. Use a complementary (colors opposite one another on the color wheel) scheme when you're aiming for something more dynamic.

I am working on an icon of the Mother of God with the Christ Child. The icon is dominated by her deep, cherry red robe and the only strongly contrasting color is a bright green on part of the child's robe. For the background, I'm using traditional yellow ochre. The border is an earthy orange with a yellow wash. As a result of this basically monochromatic scheme, a wonderful unity is emerging. The icon is calm and soothing.

Another time, I painted an icon of the Mother and Child with a dark blue background, and then used an earthy orange for the border. Red and green, blue and orange are on opposite sides of the color wheel. The effect of this complementary color scheme is an icon that's striking, alive, and vibrant.

Using your color wheel, experiment with these two ways of creating color combinations. You'll notice that each approach yields a vastly different result. Reflect on the effect you wish to create. In general, you'll want to avoid using background colors that are too closely related to the dominant robe color or your figure will disappear into the background.

Some iconographers contend that there are only two or three appropriate colors for an icon background, usually in the yellow ochre family. And yet, there are numerous examples of icons with red, green, turquoise, blue, brown, and sometimes even black backgrounds.

In fact, you could make a case for almost any background color. Do some research. Study the masters. Buy a color wheel. Pray.

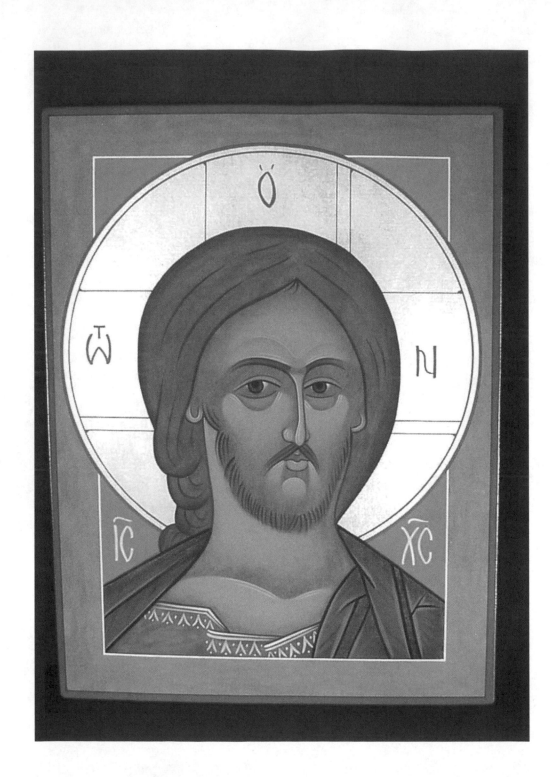

— CHAPTER FOUR —
Icon Painting Techniques

Technique is one piece of the foundation of the art of iconography. Along with study and prayer, it forms the core of what is required of an iconographer who wishes to progress in this vocation. Much of what is said in the following pages may seem abstract or confusing to the beginner. But after you have painted a few icons, it will become clear that there are useful points verbalized here that become obvious as a result of experience. Above all, keep in mind that you are trying to render something which is believable and not necessarily accurate. This is art, not science.

AN OVERVIEW OF ICON STYLES

The tradition of iconography is dominated by three main and distinct styles: Greek,[9] Russian,[10] and Coptic.[11] Yet even these styles are divided further into sub-groupings based on geography, date, and the school founded by specific iconographers. Although these three share many similarities in composition, color, and technique, there are dramatic differences among them. In addition to these three classic styles, a contemporary style is emerging, one that seems to combine the best elements of all the traditional styles.

The Greek (Byzantine) Style

- Colors are highly opaque.
- The color palette is richly diverse.
- Figures reflect the classical (Greek) idea of beauty (that is, people are muscular—Olympic—in appearance).
- Sankir (*Gr: proplasmos*), the base color of flesh, tends to be an olive green.
- Backgrounds tend to be finished in gold leaf.
- Garment folds are generally highlighted to a greater extent, rarely shadowed.
- Halos are always finished in gold leaf.
- Inscriptions are in Greek.

The Russian Style

- Colors have a very transparent quality.
- The color palette far more restricted; sometimes only four or five colors are used in various combinations.

- Figures are rendered to emphasize length, gracefulness of line and, at times, an almost surrealistic distortion.
- Sankir, the base color of flesh, can range from green, to olive, to reddish-brown to an almost blackish-brown.
- Garment folds as well as background elements tend to be highlighted to a lesser degree, if at all. There's some shadowing.
- Halos can be gold leafed or rendered with a yellow-white or some other color.
- Inscriptions are in Old Slavonic.[12]

A few years back, I was privileged to see an exhibit of old Russian icons at the Walters Gallery in Baltimore. What I found, on close inspection, was that the images almost melted away and were infused with a wondrous quality, filled from within with light. The colors were so transparent that they seemed to dissolve before my eyes. Everything about an icon should speak of this melting away of the physical into the spiritual.

The Coptic Style

- Colors can be either transparent or opaque.
- The color palette is limited and sometimes lacking in subtlety.
- Figures are cartoon-like, almost dwarfish.
- Garment folds are sometimes highlighted, but not to the extent of the Greek style.
- The images include many talismanic symbols and decorations.
- Inscriptions are in Ethiopian, Coptic, or Geez (a Coptic liturgical language).

The Contemporary Style

Still in development, this style is difficult to define. Contemporary iconographers draw upon everything that has come before to create a new expression of this liturgical art. We distill and digest until what we create is both new and old, traditional and contemporary.

SHADING AND HIGHLIGHTING

Shading and highlighting bring life and dimension to painted icons. Many iconographers refer this part of the process as "opening" the icon. This is the point at which the image is transformed from a cartoon, albeit one enhanced by a few colors, into one with depth, richness, and life. Although we're not attempting naturalistic rendering, we are creating the illusion of volume on a two-dimensional plane. At the same time, some conventions of naturalistic painting do not apply.

For one thing, an outside source of light doesn't exist in iconography. In conventional renderings, the presumption of an exterior light source dictates how shadow and light are depicted. In iconography, the source of light is God's presence emanating from within the holy one you're painting.

Also, iconographers generally do not blend wet pigments directly on the canvas to create gradations of color. Rather, we create visual transitions from shadow to base color, and from base color to highlight by layering wet color over dry. Subtlety depends entirely on the icon style, image size, or the specific parts of the icon being rendered. The Russians, for example, generally use softer transitions than the Greeks. Large church images demand bolder contrasts to be "readable" from a distance. Garments tend to be highlighted more dramatically than skin tones.

A Practical Exercise (Creating a Map)

Try this practical exercise to practice shading and highlighting without experimenting directly on a panel:

1) Photocopy your line drawing onto colored paper that isn't too pale or too dark. Allow the paper color to be your base color.

2) Before beginning, study your prototype or icons with similar poses or compositions. Can you see where shading or highlights have been applied? No? Then, study the images a while longer. Eventually, your vision will shift and these subtle changes in tone will become easier to see.

Shading

1) Mix a bit of raw umber (or a similar dark color) with water until it resembles deeply colored water.[13]

2) Begin applying this shadow tone in the appropriate places, being careful not to do too much shadowing. Remember, base colors are basically shadow tones; you're simply accentuating the deepest shadows. On many icons, these are found around edges of the body and in the deep folds of garments.

3) Now, take some time to discern where shadows will be deepest, and then build up thin layers of color to darken the shadows in these areas. Try to achieve subtle gradations of shadow that seem to melt into the base color of the paper.

33

Highlighting

1) Take a new sheet of paper with the photocopied line drawing or use the page on which you've already practiced shadows. Use white for this highlighting exercise.

2) Using translucent layers of white, begin brushing or drawing in areas of highlights. Notice how the layers become more opaque and distinctive as you build them. Remember, there is no external light source in an icon, so whatever sticks out most will get lighter.

3) Be careful about getting too carried away. Only main folds of a garment should get a lot of work. Faces should be brightest at the cheek bones and on the nose, chin, and brows. On hands, knuckles are the brightest. On hair, only locks near the face should get much highlighting.

Good icons are subtle in many ways. Study the masters, especially the Russians, and you'll discover this to be the case. With practice, you'll find that you actually have less rather than more to do of both shading and highlighting. Still, each brush stroke is important, so take your time and let nothing be taken for granted. Next to line drawing, the ability to depict shadow and light is the most important technical skill you'll need in iconography. Not surprisingly, this is where many novices encounter their greatest challenges and frustrations. Study and practice are what separate beginners from masters. It took almost fifteen years before I began to *understand* highlighting, so don't be discouraged if you don't get it right away. In icon painting, as in life, practice is the only way to improve. Be patient.

Garments
Highlighting

Effective garment highlighting begins—as always—with a good drawing on which the folds are clear and confident. Where to begin?

Think of a topographical map that shows different elevations for mountains, hills, and land masses. Each higher point is set upon something lower. You can apply this principle to highlighting a garment: Always build subsequent highlights upon the foundation of your first highlights, covering less area with each additional highlight. This makes the proper placement of your first highlight crucially important.

Here's another way to express this: Whatever sticks out the most gets the most light. Thus, the most prominent folds and features will receive the most dramatic highlights, whereas the parts of garments and the body that recede most dramatically will remain untouched or receive some shadowing.

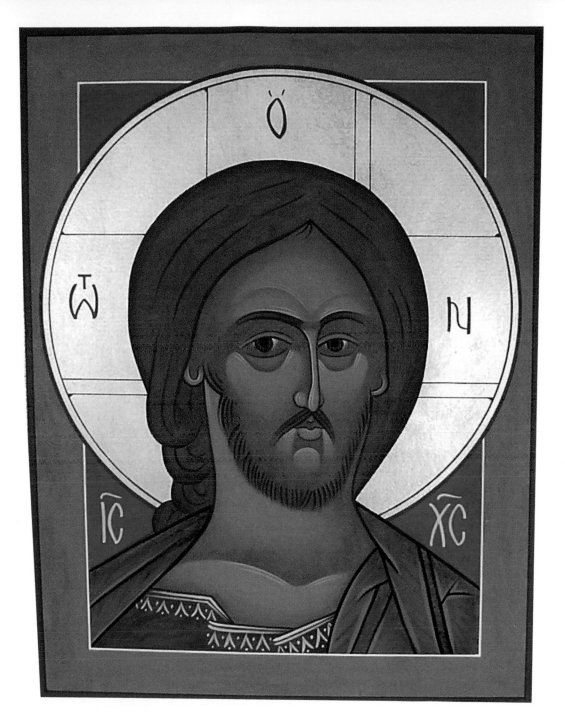

Christ the Savior

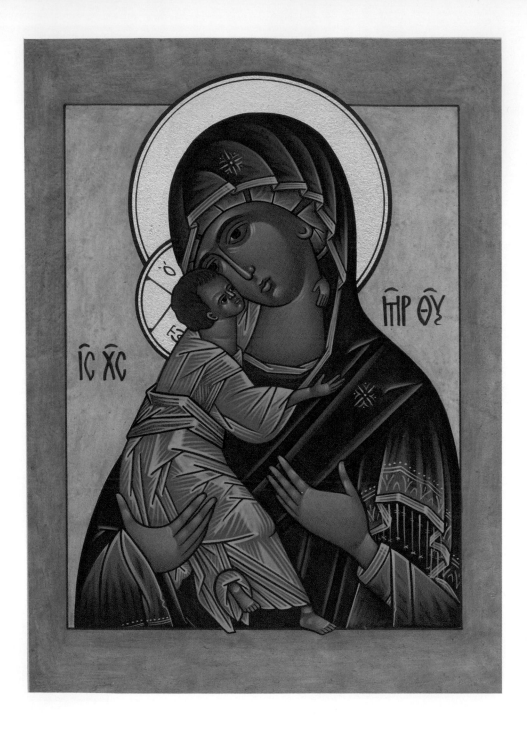

The Virgin of Vladimir

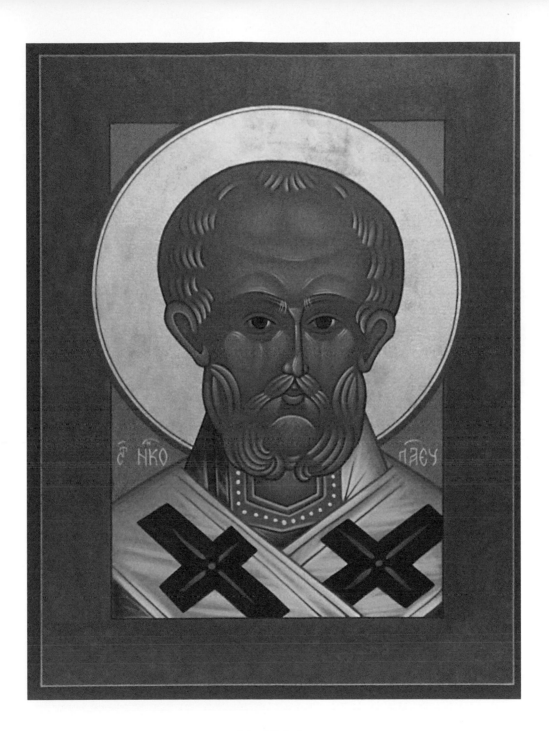

Saint Nicholas

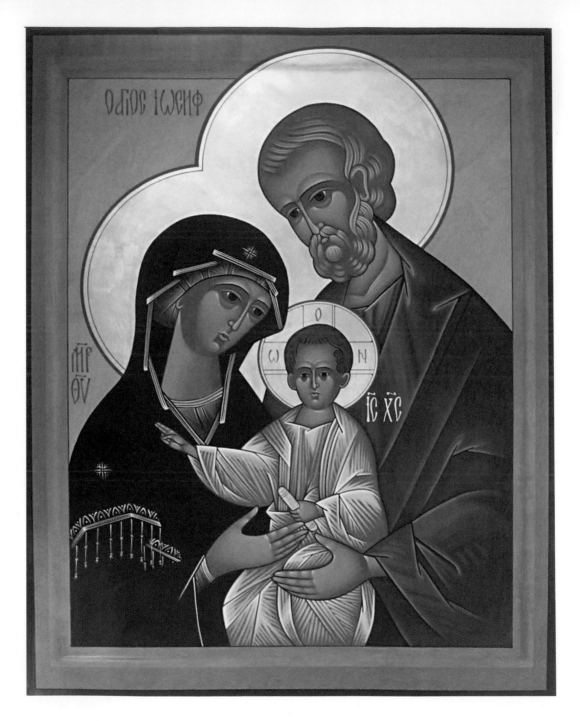

The Holy Family

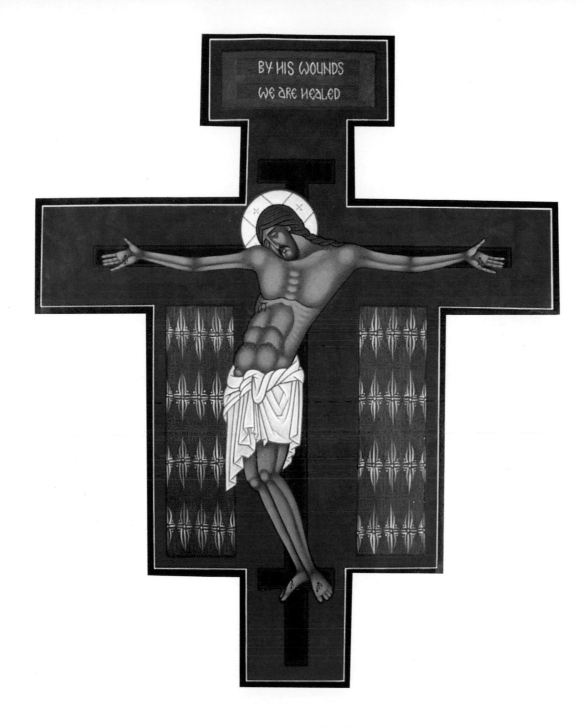

Italo-Byzantine Crucifix

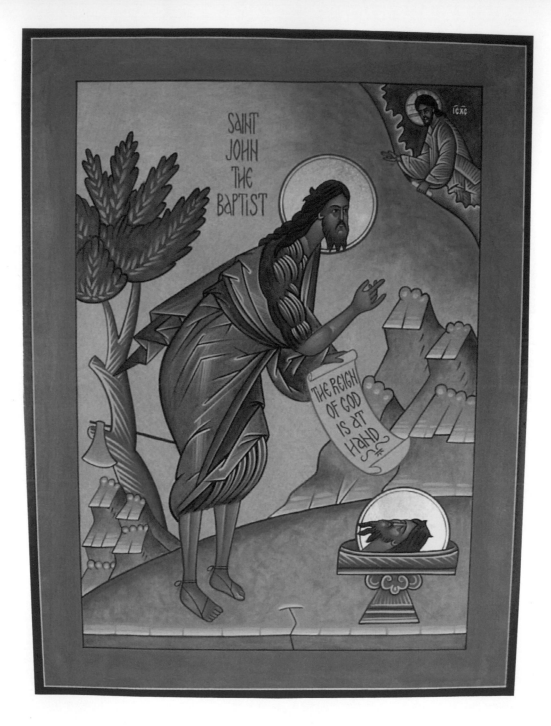

Saint John the Baptist (forerunner)

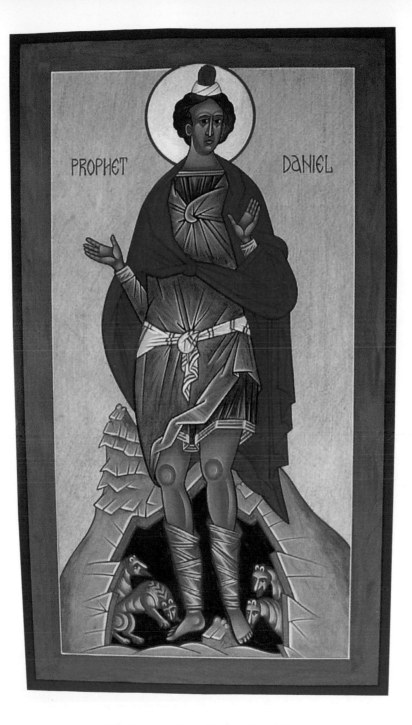

The Prophet Daniel in the Lions' Den

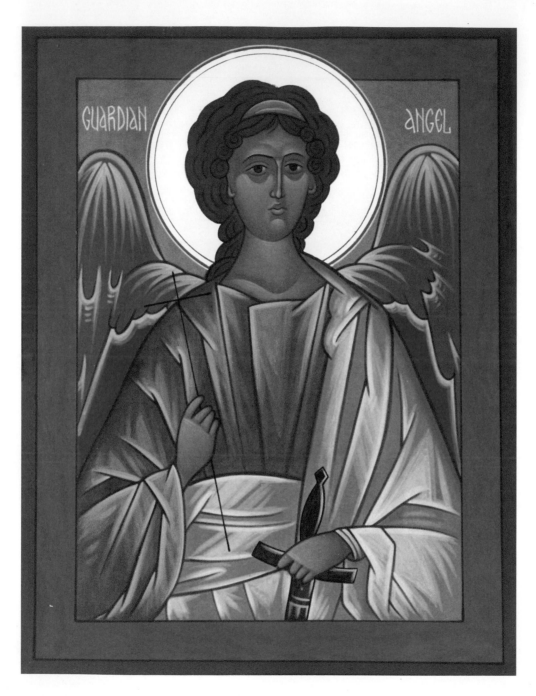

The Guardian Angel

Again, study the masters. You'll notice how the Greeks tend to work garments far more than the Russians, who sometimes leave certain areas completely untouched. What are they attempting to reveal about the body beneath the cloth? Notice how one leg may be placed a bit more forward than the other, or how the mass of an arm is communicated through highlighting. You'll also notice that some garments are highlighted with a completely different color to create an ethereal effect called a "double reflection." This technique is used often in icons of the Novgorod School.

In all icons, garments are highlighted in an attempt to enhance the image and to make it more understandable. Icons point to reality; they do not render it. Consequently, iconographers often place highlights right up against the folds of the garment. This contrast of dark against light is what gives figures the appearance of being not completely flat without attempting photorealism.

You'll see three basic types of highlighting in icons created by master iconographers.

1) Starbursts and "railroad tracks."[14]

2) Geometric shapes.

3) Subtle washes of a highlight finished off with a brighter line of color right up against the fold.

You needn't do the same amount of highlighting on every area of the garment. You may wish to stop after one or two highlights for minor areas but continue on for more dominant folds. It will take time to find a method that works best for you. Don't hesitate to study any of the readily available and excellent reproductions to understand these techniques better.

Shading

Occasionally, subtle shading is done on certain areas of clothing such as those areas around the edges of a figure. You'll notice this more often in Russian icons. Keep shading to a minimum, especially when you start out. And always avoid using colors that are too deep and opaque.

The shadow should be either a slightly darker shade of base color, a contrasting color, or done with washes of raw umber. Shadowing has its advantages. The more shadowing you use, the less highlighting you'll need to create a credible garment.

Double Reflections

When used prudently, double reflections produce a wonderful effect, resembling the dramatic changes of color you can see in folds of Thai silk or taffeta. In the Russian schools, double reflections are created mainly by applying blues on reds, browns, and greens. The Greeks appear to have no set

ideas about double reflections; they use a variety of contrasting colors to accent a robe. Just be careful not to overdo it. One double reflection per icon is enough.

White Garments

Although it seems that you could just paint a garment area completely white, this is rarely effective. You have two other options. First, you may use another color, such as yellow ochre or light blue, as your base, and build toward white from there. Alternatively, you may paint the garment off-white, then lay in some subtle shading and highlight sparingly with white. When you outline a white garment, you'll want to avoid drawing lines that look dark and heavy, so use an orange-yellow or raw sienna.

Gold Garments

You can best communicate gold cloth by starting with a base color that's earthy-orange or red. Highlight with hatch lines of Turner's yellow (yellow and white) or use fine lines of gold leaf instead of paint. Prudence is essential; too much gold can make an icon look gaudy.

When I began painting icons the process of highlighting the garments was one of the most challenging aspects of the art. It took a long time before I had the vaguest idea of what I was doing.

Somewhere along the way, things began to make sense, but not in a cerebral sort of way. I kept rendering the clothing poorly until I finally got some understanding of what I was trying to achieve—and it was a gut feeling rather than a formula.

If it were possible to verbalize anything about what I've learned, it would be simply that whatever stands out the most gets the highlight. There's a great deal to learn about effectively painting folds and highlights on garments. Much of what you need to learn evades any simple formulation. All I can say is this: Keep at it and it will begin to make sense. Eventually.

Decorative Elements

Sometimes garments are overlaid with decorative elements that enhance elegance and add visual interest to the figure, such as the cross patterns on the garments of bishops. Don't worry about how the folds would break up the pattern if you're adding decoration or embroidery on clothing. Simply apply the ornamentation over the garment consistently. You may wish to do some transparent shading or highlighting over the pattern once it's in place. It doesn't have to be accurate; it just has to be credible. The effect will be rich and beautiful.

Flesh Tones

You'll be able to create flesh tones on any icon by laying highlights on the base color sankir/proplasmos, which can be created several ways:

For a basic olive green sankir/proplasmos: Mix your first highlight color (see recipe below). Pour approximately half of the first highlight color mixture into a small container. Add drops of black until the mixture becomes olive green. Black is a very potent color, so add just a bit at a time.

For a browner sankir/proplasmos: Combine pine green (green with a yellowish tint) or olive green and gold oxide or Mars yellow (an earthy-orange).

For a more neutral sankir/proplasmos: Mix yellow ochre and raw umber.

Next we will add layers of lighter colors over certain parts of the base color to give volume to the skin areas. Noses, cheeks, fingers, ankles, etc. will emerge as highlights are painted onto the base color.

1) For your first highlight color, mix yellow ochre (yellow earth or yellow oxide) with some bright red (napthol red light) to create a tangerine orange. Use this for your first highlight and for the foundation of sankir/proplasmos.

2) For your second highlight color, use only yellow ochre (yellow earth or yellow oxide), or begin adding yellow ochre to your first highlight color (tangerine orange) in small increments.

Instead of mixing a base color for skin areas, one of my teachers applies alternate layers of transparent yellow ochre, green oxide, and bright red. The visual mix of these layered colors creates a base tone that can be adjusted, either by adding more glazes of a needed color or by diminishing the layers that need muting. This technique provides a rich and interesting foundation for later highlights.

37

3) Subsequent highlights: Add a bit of white or off-white to the yellow ochre. Be careful not to use too much white or the flesh tones will begin to look washed out and chalky.

4) Enliveners (small white hatch lines used to accent the brightest places on skin and the "glisten" in eyes): Add a bit more white or off-white to the yellow ochre.[15] Enliveners are usually rendered as parallel lines, sometimes two, sometimes more. The "glisten" in the eye is a small teardrop of this color painted right up against the edge of the iris using the enlivener color.[16] Do *not* put a "glisten" on the iris because that would indicate reflection from outside. (Please, no Precious Moments!)

An overall suggestion about skin tones: Each thin layer must be applied with a light touch, the colors almost transparent so that transitions appear soft and natural. While you can be more dramatic in highlighting clothing and background details, flesh areas must be more subtle. The darkness of the sankir/proplasmos you mix will determine how much highlighting you'll be required to do.

HAIR

Icons generally represent hair as being either brown or gray, and black only in rare instances. For the most part, hair can be rendered easily and effectively.

Brown Hair

Create brown hair by:

1) Painting the area with sankir/proplasmos when doing other parts of the flesh areas, then washing over this with brown or burnt sienna mixed with a bit of dark green to deepen the color.

2) Shading around the outside edge of the head with raw umber.

3) Highlighting the locks of the hair with a mixture of burnt sienna, some yellow ochre, and a bit of red. Lighten this color even more to accent the locks.

4) Highlighting the edges of the locks with yellow ochre with a fine brush.

5) Gently outlining selected locks and around the edge of the hair with a darker brown.

Gray Hair

Create gray hair by:

1) Painting the area with sankir/proplasmos or basic skin tone, perhaps with a bit of blue added.

2) Shading around the outside edge of the head with raw umber.

3) Adding a bit of white to the base color to create major locks toward the face.

4) Adding even more white to the highlight color and accenting selected locks.

5) Outlining the edges of hair and selected locks with sankir/proplasmos mixed with a trace of black.

Black Hair

Recently at an outdoor arts festival I was listening to a group of native musicians from South America. I noticed that their hair was so black that it seemed to have blue highlights. It was beautiful. So, create black hair by:

1) Painting the area a dark color created by mixing dark brown and dark blue in a 50/50 mix.

2) Highlighting with a mixture of base color, some white, and blue.

3) Continuing to highlight by mixing in more white.

4) Outlining selected locks with black.

Avoid using pure black for hair.

Beards

For a brown beard:

1) Begin at the bottom with dark brown (for example, burnt sienna with some dark green).

2) Slowly add more burnt sienna and work up the face.

3) Allow this color to melt into the sankir/proplasmos of the skin so it looks blended instead of merely sitting on top of the face.

4) Finish by painting in some dark lines toward the bottom of the beard to create a clearer contrast with the neck.

Remember that beards generally grow from ear to ear. For a more subtle appearance, apply washes of burnt sienna that gradually fade up into the face and then apply darker strokes to create the illusion of an edge at the bottom of the beard.

Grey beards are done in the same manner as grey hair.

HALOS

Although halos can always be painted a yellow white, they are often gold leafed. The procedure for adhering gold leaf is basically the same for both water- and oil-based sizes.

39

1) After you've finished painting, cover the area to be gold leafed with a thin layer of size. If oil gilding, work from the center outward in every direction to prevent large amounts of size from building up along the edges and oozing onto painted areas. If you're water gilding, add a bit of red paint to the size before you begin. Use a full brush of water to enhance the flow of size, but do *not* allow puddles to form. Cover the area completely, and then stop! Do *not* try to touch up, improve, smooth, or futz. You can return later to patch these spots after the initial layer of gold is applied, but only with the water-based sizes. Oil-based sizes have drying times that can range from two to twenty-four hours. Read the label completely and try testing a piece before using these products. Water-based size dries in minutes, longer under humid conditions. Both kinds of size will remain tacky for a period of time once it's dry; the length of this time depends on the amount of humidity in the air.

2) After the size has dried sufficiently, apply the gold. I recommend using patent gold, which is easier to handle. Remove a leaf from the book and apply it face down onto the surface of the size. Do not attempt to move it once it touches the size. Holding the tissue in place with one hand, use medium pressure to rub the surface of the tissue where size touches gold. Lift the leaf by the edge of the tissue. The gold will stick to places that were sized. Sometimes excess gold will come away from the tissue. Don't freak out! You can brush this away later. Move on to the next area.

3) Cover all large areas to be gilded first, then go back with the scraps and touch up spots you've missed.

4) Using the empty tissue as a barrier between you and the gold, use a natural fiber cotton ball to rub over the gilded areas to reinforce the adherence of gold to size.

Although I am guilty of using all manner of gold paint for halos over the years, I have come to the conclusion that anything fake has no place in these images of the truth of God. If you cannot get gold leaf, simply use a yellow mixed with a bit of white for the halo.

5) Remove the tissue and, with small circular motions, wipe away excess gold with a soft bristle brush. Save the excess in a can for other projects.

6) Now, lightly buff the gold with the natural fiber cotton ball. If any gold adheres to areas where you did not apply size, simply use a brush, moistened with saliva, to work the gold away. Again, use circular movements, being careful to avoid sized areas. If you missed any spots on the gilded areas, you can try a moist hot breath and application of gold or touch up with size (only the water-based method) and gild those small areas.

40

7) You're now ready to outline the halo and, in the case of Christ's halo, add ornamentation. Sometimes you may wish to tool the gilded areas by gently tapping a small nail or leather punch. In any event, seal the halo with a good sealer before varnishing with a water-based varnish. It can be frightening to see the halo line float away when water separates the paint from the gold.

Another unusual type of halo is used on figures of Holy Wisdom, the Lord Sabbath, and Holy Silence. In these, an eight-pointed star is superimposed on the circle (the lowest point of which is hidden by the head) and these are painted in red and blue alternating points.

INSCRIPTIONS

Inscriptions identify the figure, but also join the written name with the image, which was very important to ancient cultures. The language used (for example, Greek or Slavonic) reflected what was spoken where the icon was created. Although using a foreign and ancient language may add some exotic flair to an icon, it's not necessary—with two exceptions: icons of Christ and the Theotokos.

On images of Christ, you'll see the Greek inscription: IC XC (with a wavy line over each set of letters). This is an abbreviation for Jesus Christ. You'll also notice a cross in the halo that is plotted by using the center point of the halo. It has three arms: one above and two on either side of the head. In the arms of the cross are painted the Greek letters: ωTN, which means "the being" (a Greek equivalent of "I AM," the name of God given to Moses in the desert).

On icons of Mary, you'll notice the Greek inscription MP ΘV (with the wavy lines and the O with a short minus line through it for the Greek letter theta) and this is an abbreviation for Mother of God. Otherwise, you may use English.

Lettering for inscriptions is often a Hellenized or a Slavonic-inspired form of our alphabet. I've designed an alphabet, but you need not copy it slavishly.

LINES

Painting long, straight lines is a necessary part of the icon process, especially when laying in the pinstripes that divide large areas of color. Many iconographers still prefer hand-painted lines that are always imperfect in some way, but still believable because of the confidence with which these lines are painted. And these "good lines" come from your commitment to practice and your willingness to accept a line with "soul"

ΚΥΡΙΕ

ΑBCDEFGHIJKLM
HOPQRSTUVWX
YZ 1234567890

ΑBCDEFGHIJKL
HNOPQRSTUV
WXYZ ΚΥΡΙΕ

rather than one that's mechanically "perfect." My advice is that you practice on something other than your icon first, that you do not think about it too much, and that you don't get involved in line-drawing crutches like masking tape, which can cause more problems than they're worth. Just paint a line—you can do it! As one of my students notes: It doesn't have to be "perfect" to work.

For the faint of heart, there's another solution that will also require a certain amount of confidence. Pinstripes, whether straight lines dividing the image from the border or the inner border from the outer border, and curved lines, such as the outline of the halo, can also be rendered with a ruling pen. For curved lines, you can use a ruling pen attached to a compass. These pens were commonly used in drafting before the age of computers and can be found in art stores as well as architectural supply catalogs. The ruling pen, with some practice, will yield a perfect, although mechanical, line. Be fore-warned, there are some technical concerns that you must master in order to use a ruling pen well:

- Look for old drafting sets at flea markets and yard sales whenever possible. If you buy a new set, sand or file down the point because new ones have a tendency to be too sharp and will scratch through the paint if too much pressure is applied.

- Create a consistency of paint that's neither too watery nor too dry. Only practice will teach you this.

- There's a little button on the pen for opening and closing the mouth of the pen. Don't attempt to create a wide line by opening it too much, or all the paint will flow out immediately. Create wider lines by doing several thin lines side-by-side.

- Don't load the pen too much; the viscosity of water will allow only so much paint to be loaded before it leaks out.

- Keep a clean, dry cloth nearby to clean the pen after loading it with paint—before going near the icon.

- Using a cork-backed ruler as a guide will prevent paint from leaking back under its surface.

- Keep the button pointed away from you as you paint the line. (Trust me.)

- Practice on paper first.

- When you begin a line, keep going because the paint will continue to flow and you could end up with blobs of paint where you don't want them.

- If the paint doesn't flow out well or you get gaps in the line, don't try to force it by pressing harder. Stop and add more water to the mix, reload the pen, and then try again.

- Don't go back and forth with the pen. Move only in one direction.

- Correct errors by resculpting errors, such as blobs, with small additions of more base colors instead of wiping away a line that's good enough.

These directions apply to the ruling pen used alone or combined with a compass for doing halos and curved lines. When you pinstripe a gold-leafed halo, don't attempt to wash away any paint that has gotten onto the gold. This will ruin your gold. Instead, lightly touch a small piece of paper towel to the still-wet blob. This will absorb much of the paint all by itself. Remember that the gold is extremely fragile. Practice, practice, practice first.

ICONS AND CHILDREN

Iconography is not only for adults. Over the years, I've introduced many teachers and schoolchildren to the prayer and practice of creating icons. In each case, the teachers have found this a wonderful way to give students a hands-on experience of praying with a paintbrush while exploring the rich history of our faith. Often, the icons they create are part of a larger introduction to the Christian East, prayer, or the liturgical seasons. Kids really enjoy the project and these icons quickly become family treasures, inviting the domestic church—the family—to create places of prayer in their homes.

— 43 —

One possibility that seems to work really well is to have the children create icons during Advent, while reading and discussing Eastern Christianity, then allowing them to bring their finished icons home as a Christmas present to their family. You will be amazed at the impact of the process on the kids as well as the enthusiasm it creates within the families.

Naturally, iconography technique has to be simplified for young students. To make it manageable for elementary school children, fix a photocopied line drawing of the icon directly onto the wooden panels using a decoupage (pasting) technique. Here are the steps:

- Make copies of the line drawing.

- Have an adult cut panels to the appropriate dimensions and sand the edges.

- Mix white glue with water (two parts glue to one part water).

- Paint the mixture onto the board's surface and allow it to dry for two hours.

- Dip the photocopy into a shallow pan of the glue mixture and transfer the drawing to the board.

- Gently smooth with the hands or a soft cloth, pricking stubborn bubbles with a pin to release these pockets of air under the surface.

- Let the panels dry overnight.

- With a razor blade, trim away the excess paper from the edges of the panels.

- Sand the edges again, rounding the top edge a bit (be careful not to pull the print away from wood).
- Apply several layers of the yellow ochre or orange glaze on the surface as in the normal technique.

- Allow the kids to paint their icons.

- After students have completed their icons, paint the backs and the sides with deep red latex paint.

- Varnish the icons in the same manner as mentioned earlier.

- Have the icons blessed and allow the budding iconographers to venerate their icons.

 I am an iconographer today because of one of my childhood teachers. So never underestimate how significant this experience could be for the children in your care.

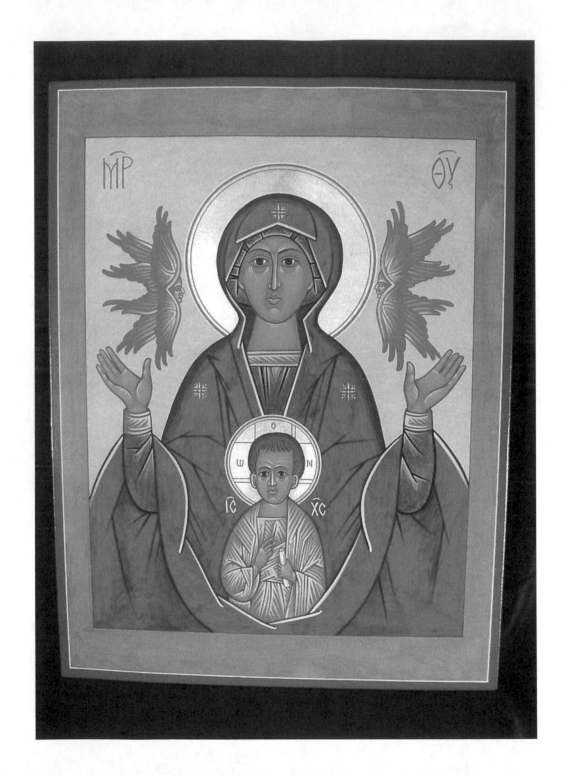

— CHAPTER FIVE —
Three Icons Step-by-Step

In this chapter, you'll find directions for three icons: Christ, The Virgin of Vladimir, and Saint Nicholas. I've chosen these images for a number of reasons.

The Christ icon is simple and allows you to work on a face with a beard—not to mention the fact that Christ is the icon/image of the invisible God, whose incarnation has made it possible to create *any* image of God.

The Virgin of Vladimir icon provides an opportunity to paint two faces without beards—one of an adult and one of a small child. This also allows us to begin working with hands as well as the folds of garments, double reflections, and garments that shimmer like gold. The Virgin of Vladimir is especially loved in Russia, where it was brought from Constantinople shortly after Russia's conversion to Christianity over a thousand years ago.

The Saint Nicholas icon will let you practice rendering gray hair on an image of this beloved saint and bishop. In fact, the Russians have such a love for Nicholas that they sometimes remark, "If God dies, we still have Saint Nicholas!"

REMINDERS ABOUT THE PROCESS

Before starting your icon, please read through all directions very carefully. Remember, you have a great deal of freedom in your choice of background and border colors. Also, you're under no obligation to use the same shades of color as are on the prototype—for either base colors or highlights. Simply stay within the general family of colors suggested.

Background elements, architectural details, vegetation, and other details (when, and if, they exist) can be rendered to suit your tastes. At the same time, especially for beginners, it might make this project less challenging and anxiety provoking if you simply paint what you see on the color prototype.

Spend some time with the prototype, as well as with the line drawing, before beginning (see Chapter 1). It might be helpful to look for other examples of the same icon in books, calendars, and other sources. I recommend reading whatever you can about the image and the person portrayed. This will help you know and understand who you're trying to communicate through color and line. Above all, pray. Ask the Holy One, whom you paint, to be present and to assist you in your efforts.

Finally, do not *futz*! Working and reworking an icon often makes it worse rather than better. Learn from your mistakes and do it better the next time. An icon is not painted by the force of your will. On the contrary, you must get out of the way; be an instrument.

At every step do your best, and then move on. If you create beauty at each step of the project, how can the outcome be anything less than beautiful? For heaven's sake, try not to compare your work with mine. Remember, I've had a bit more practice! You'll get better and better if you keep at it. For now, be fully where you are.

CREATING IN THE GREEK STYLE

- Begin with a drawing or tracing of a classical icon originating from the Mediterranean area, from any historic period.
- After transferring your drawing to the board, simply fill in the base colors until they are quite opaque. You'll need to redraw lines that define the folds and facial features once the base colors are completed.
- Highlight by painting another three layers, each one a lighter color than the base color. These highlights are also opaque and each one is slightly smaller in area than the preceding highlight.
- Outline and reinstate original lines of the drawing with the base color mixed with a bit of black.

CREATING IN THE RUSSIAN STYLE

- Begin with a drawing or tracing of a classical icon originating from any of the Russian schools. Avoid using icons produced after the fifteenth century because of Westernizing influences.
- After transferring your drawing to the panel, use a fine brush to paint the lines of the drawing in a dark color. This will enhance the gracefulness of the drawing and provide guidelines that will show through subsequent layers of transparent paint.
- Before filling in the base colors, wash the entire surface board with several transparent layers of yellow ochre or a reddish orange—as many as five. This will add warmth to colors applied over it.
- Keep your palette simple, using as few colors as possible.
- As you fill in the base colors, make sure they are transparent and somewhat mottled. Make sure you can still see the lines you've drawn.
- Once base colors are filled in, lay in shadows where necessary, using either complementary colors or raw umber. Don't get carried away with the amount of shadow or its darkness.
- At this point, you can begin highlighting the garments. Be frugal. Remember, this style tends to less rather than more ornate.
- Build up flesh areas first with tangerine orange, then yellow ochre, and finally yellow ochre mixed with a bit of white.
- Add the enliveners and eye glistens with yellow ochre mixed with a bit of white.

- Outline with darker shades of the base colors or a combination of red (red earth) and black, except on white garments and skin. Use more red for lighter colors and more black for darker colors. For outlining white garments, use yellow ochre or raw sienna mixed with red (red earth). For outlining skin areas, use burnt sienna or a raspberry red.

THE ICONS
Beginning the Process

Each of these icons begins with these same steps:

1. Trace the drawing.
2. Transfer the image to the panel.
3. Paint in drawing's lines.
4. Apply yellow ochre/oxide/earth washes to the panel.

What follows are specific directions for each icon and "maps" (for example, illustrations of where to place each successive highlight). See insert for color renderings of each icon.

Christ Head and Shoulders
Once the drawing is on the panel and the yellow layers have been applied, follow these steps:

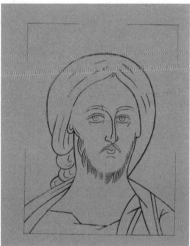

1) Paint in base colors for each area. Do this by applying several thin (but not watery) layers of color in each color area with short, multi-directional brush strokes. Layering will level out the color as you go. Pay no attention to folds and other details; just fill in the areas, trying to create intense color without loosing translucency. You should be able to see the lines of the folds and face through your paint at all times.

- Background: red (Napthol Red Light*)
- Outer garment: dark blue (Storm Blue*)
- Inner garment: deep red (Indian Red Oxide* or Brown Madder*)
- Skin and hair: sankir (see Flesh Tones, page 36, 37)
- Hair on top of head: burnt sienna* washes over the sankir (2–3)
- Border: sankir

- Outer border (¼" all around) and edges of panel: brick red (Red Earth*)
- Halo (if not gold leafed): Turner's Yellow*

2) Now, apply shadowing and highlights. Please refer to the "maps" for each successive highlight to get an idea of the placement and area of each highlight. Expect to do several layers of each shadow and highlight. Again, keep your paint thin and translucent so the transitions of color will be subtle.

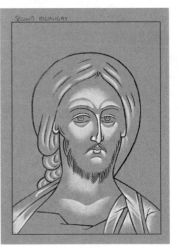

- Outer garment: no shadow
 - 1st highlight: dark blue (Storm Blue*) plus a bit of Turner's Yellow*
 - 2nd highlight: add a bit more Turner's Yellow* to first highlight color
 - 3rd highlight: add a touch of white (Titanium White*) to second highlight color
- Inner garment: no highlights or shadow (embroidery added later)
- Skin: no shadow
 - 1st highlight: tangerine orange (Yellow Oxide* or Golden's Yellow Ochre plus Napthol Red*, 50/50)
 - 2nd highlight: earthy yellow (Yellow Oxide* or Yellow Ochre)
 - 3rd highlight: earthy yellow plus a bit of white (Titanium White*)
 - Enliveners and "glisten" in eyes: add a bit more white to the 3rd highlight
- Hair: shadow with Raw Umber* around edge of the head; no highlights

3) Add details.

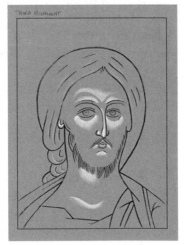

First Highlight

Second Highlight

Third Highlight

- Embroidery on inner garment: Turner's Yellow*
- Irises of eyes, eyebrow areas, moustache area, and beard area: burnt sienna (on beard, make sure you have the color deepest at the bottom and fade it up into the face for a more natural appearance)
- Lettering over each shoulder: Turner's Yellow* plus white

4) Original lines of the drawing are now reinstated.

- Inner garment: deep red plus a bit of brown (Brown Earth*)
- Outer garment: dark blue plus a bit of brown (Brown Earth*)
- Pupils of eyes, outline of irises, and upper eyelash: use a very dark color (Storm Blue* plus Brown Earth*, 50/50)
- Other skin lines: Burnt Sienna*
- Hair (including beard lines, moustache lines, and eyebrow lines): brown (Brown Earth*) You may want to add a touch of dark blue to this if you need to make it darker.
- Pinstripe between image and border: Turner's Yellow* plus white
- Pinstripe between border and outer border: Burnt Sienna*

5) You can now gold leaf the halo if you wish. Then, lay in the pinstripe that forms the outline of the halo with brick red (Red Earth*), the lines of the cross, and the inscription of the halo. Once that's done, go back and re-clarify the outline of the head and shoulders so that there's a clear line between the gold and the paint.

6) Make any necessary corrections and varnish the icon.

Vladimir Mother of God

Once the drawing is on the panel and the yellow layers have been applied, follow these steps:

1) Paint in the base colors for each area. Do this by applying several thin (but not watery) layers of color in each color area with short, multi-directional brush strokes. Layering will level out the color as you go. Pay no attention to folds and other details; just fill in the areas, trying to create intense color without loosing translucency. You should be able to see the lines of the folds and face through your paint at all times.

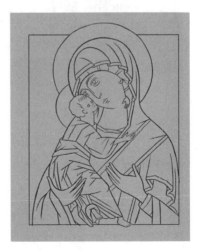

- Background: earthy yellow (Yellow Oxide*)
- Mary's sleeve, shower cap, and Jesus' sash: blue (Storm Blue*)
- Mary's outer robe: maroon/purple (Indian Red Oxide* or Brown Madder*)
- Jesus' garment and trim of Mary's robe: red/orange (Norwegian Orange*)
- Skin and hair: sankir
- Hair: Burnt Sienna* washes over the sankir (2–3)
- Border: sankir
- Outer border (¼" all around) and edges of panel: deep red (Indian Red Oxide* or Red Earth*)

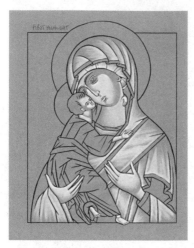

First Highlight

2) Now apply shadowing and highlights. Please refer to the "maps" for each successive highlight to get an idea of the placement and area of each highlight. Expect to do several layers of each shadow and highlight. Again, keep your paint thin and translucent so the transitions of color will be subtle.

- Mary's sleeve and shower cap: no shadow
 - 1st highlight: blue (Storm Blue*) plus a bit of Turner's Yellow* and a bit of white (Titanium White*)
 - 2nd highlight: add more white (Titanium White*) to first highlight color
 - 3rd highlight: add more white (Titanium White*) to second highlight color
- Mary's outer robe: no shadow
 - 1st highlight: blue (Storm Blue*) plus a bit of Turner's Yellow* and a bit of white (Titanium White*)

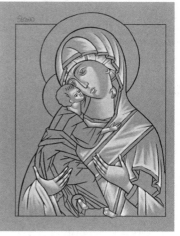

Second Highlight

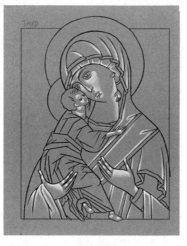

Third Highlight

- 2nd highlight: add more white (Titanium White*) to first highlight color
 - 3rd highlight: add more white (Titanium White*) to the second highlight color
- Jesus' garment, sash, and trim of Mary's robe: Turner's Yellow*
- Skin: no shadow
 - 1st highlight: tangerine orange (Yellow Oxide* or Golden's Yellow Ochre plus Napthol Red*)
 - 2nd highlight: earthy yellow (Yellow Oxide* or Golden's Yellow Ochre)
 - 3rd highlight: earthy yellow plus a bit of white (Titanium White*)
 Enliveners and "glisten" in eyes: add a bit more white to the 3rd highlight
- Hair: shadow with Raw Umber* around edges of head
 Highlight: Burnt Sienna* plus a bit of earthy orange (Gold Oxide*)

3) Add details.

- Embroidery on Mary's garment, stars, and tassels: Turner's Yellow*
- Irises of eyes, eyebrow areas: Burnt Sienna*
- Background lettering: Norwegian Orange*

4) Reinstate original lines of the drawing

- Mary's sleeve, shower cap, and Jesus' sash: blue (Storm Blue*) plus brown (Brown Earth*)
- Mary's outer robe: brown (Brown Earth*)
- Jesus' garment and trim of Mary's robe: Norwegian Orange* plus Burnt Sienna*
- Pupils of eyes, outline of irises, and upper eyelash: use a very dark color (Storm Blue* plus Brown Earth*, 50/50)
- Other skin lines: Burnt Sienna*
- Hair (including eyebrow lines and lower eyelashes): Brown Earth*
- Pinstripe between image and border: Burnt Sienna*
- Pinstripe between border and outer border: off-white (Opal*)

5) You can now gold leaf the halo if you wish. Then, lay in the pinstripe that forms the outline of the halo with brick red (Red Earth*), the lines of the cross, and the inscription of the halo. Once that is done, go back and re-clarify the outline of the head and shoulders so that there's a clear line between the gold and the paint.

6) Make any necessary corrections and varnish the icon.

Saint Nicholas

Once the drawing is on the panel and the yellow layers have been applied, follow these steps:

1) Paint in base colors. Do this by applying several thin (but not watery) layers of color in each color area with short, multi-directional brush strokes. Layering will level out the color as you go. Pay no attention to folds and other details; just fill in the areas, trying to create intense color without losing translucency. You should be able to see the lines of the folds and face through your paint at all times.

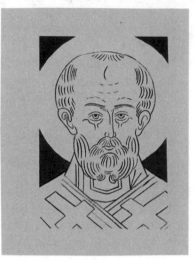

- Background: turquoise (Turner's Yellow* plus Titanium White* plus a bit of Storm Blue*)
- Inner garment: deep red (Indian Red Oxide* or Brown Madder*)
- Collar: red-orange (Norwegian Orange*)
- Omophorion/stole: off-white (Opal*)
- Skin and hair: sankir
- Border: sankir
- Outer border (¼" all around) and edges of panel: deep red (Indian Red Oxide* or Red Earth*)

2) Now apply shadowing and highlights. Please refer to the "maps" for each successive highlight to get an idea of the placement and area of each highlight. Expect to do several layers of each shadow and highlight. Again, keep your paint thin and translucent so the transitions of color will be subtle.

- Inner garment: no shadow
 - 1st highlight: medium blue (Storm Blue* plus Turner's Yellow*)
 - 2nd highlight: medium blue plus white (Titanium White*)
 - 3rd highlight: add more white to second highlight color
- Collar: no shadow
 - Highlights: Turner's Yellow*
- Omophorion/stole: shadow edges of shoulders and along creases with Raw Sienna*
 - 1st highlight: off-white (Opal*) mixed with a bit of white (Titanium White*)
 - 2nd highlight: white (Titanium White*)
- Skin: no shadow
 - 1st highlight: tangerine orange (Yellow Oxide* or Golden's Yellow Ochre plus Napthol Red*)

- 2nd highlight: earthy yellow (Yellow Oxide* or Golden's Yellow Ochre)
- 3rd highlight: earthy yellow plus a bit of white (Titanium White*)
- Enliveners and "glisten" in eyes: add a bit more white to 3rd highlight

- Hair (including eyebrows, moustache, hair on top of head, and beard): shadow around edge of head with Raw Umber*
 - 1st highlight: sankir plus off-white (Opal*)
 - 2nd highlight: add a bit more off-white to the first highlight color
 - 3rd highlight: add more off-white to the second highlight color

3) Add details.

- Pearls on St. Nicholas's collar: off white (Smoked Pearl*)
- Crosses on Omophorion/stole: greenish-black
- Embroidery on crosses: earthy orange (Gold Oxide*)
- Lettering: yellow-white (Naples Yellow*)
- Irises of eyes: burnt sienna

4) Reinstate original lines of the drawing

- Inner garment: brown (Brown Earth*)

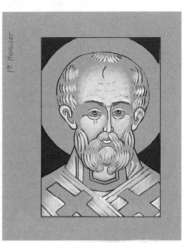

First Highlight

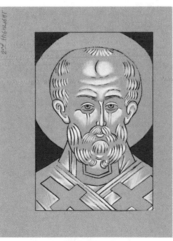

Second Highlight

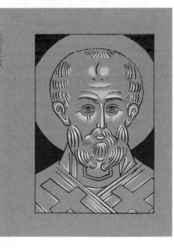

Third Highlight

- Collar: Norwegian Orange* plus Burnt Sienna*
- Omophorion/stole: Norwegian Orange* plus earthy yellow (Yellow Oxide*)
- Crosses: Norwegian Orange* plus earthy yellow (Yellow Oxide*) and maybe a bit of greenish-black
- Pupils of eyes, outline of irises, and upper eyelashes: use a very dark color (Storm Blue* plus Brown Earth*, 50/50)
- Other skin lines: Burnt Sienna*
- Hair (including eyebrows, moustache, hair on top of head, and beard): sankir plus brown (Brown Earth*)
- Pinstripe between image and border: Burnt Sienna*
- Pinstripe between border and outer border: off-white (Opal*)

5) You can now gold leaf the halo if you wish. Then, lay in the pinstripe that forms the outline of the halo with brick red (Red Earth*), the lines of the cross, and the inscription of the halo. Once that is done, go back and re-clarify the outline of the head and shoulders so that there's a clear line between the gold and the paint.

6) Make any necessary corrections and varnish the icon.

STEP-BY-STEP VARNISHING

1) After completing the icon, let it dry completely. The length of time will depend on humidity and temperature, but allow for at least twelve hours.

2) Ensure minimal airflow and dust where you'll be varnishing. You'll also want to be able to leave the area since the fumes are harmful.

3) Read the directions on the can and collect everything you'll need—paper to protect the surface of your table, foam brush, a can or something to put under the icon so it's raised off the table.
4) Stir the varnish thoroughly and do *not* shake it; this forms tiny air bubbles.

5) Dip the sponge brush into the varnish and transfer a fair amount onto the panel's surface.

6) Spread the varnish out in every direction, and then brush the panel's sides.

7) After varnishing and checking to see that no area has been missed, lightly feather the surface with a relatively dry foam brush to smooth out any puddles that may have developed.

8) With a clean, dry cloth, wipe away any drips or varnish that has bled onto the back of the panel.

9) You now have a limited amount of time to remove dust, pet hairs, and so on, so do that quickly and then retouch that part of the surface, using a feathering action with a dry foam brush.

10) Now, let the icon dry approximately twelve hours before touching it.

11) After your icon is completely dry, you may wish to apply several more layers of varnish for additional protection, but remember to sand lightly with very fine steel wool between each coat of varnish.

12) After you've finished varnishing it, you might want to paint the back of the icon with a color similar to whatever is on the sides of the panel. I use latex paint for this since it's less expensive than acrylic paint. Any good paint store can match a swatch of color. Using a clean, damp cloth, gently remove any paint that gets onto the varnished areas. You may spray the back with a protective finish.

In Summary

- Don't futz! Do your very best at every stage and then let it go. There will be other chances to do it better. Second-guessing and fixing things that ultimately won't need fixing will only make the "problem" worse.
- Ask for help. During a workshop or retreat, there will always be someone willing and able to assist you. When you're alone, try prayer. And don't forget to say "thank you."
- After all the fretting over a difficult challenge, just pick up your brush and try.
- Paint as you can, not as you think you should.
- The most revered icons are not necessarily the most technically perfect. Rather, they have a quality that I can only describe as "soul."
- Don't compare your work with that of others—that's ego and will only make you feel frustrated or proud.
- Allow yourself to appreciate the beauty that has come through your hands and heart.
- Don't point out the "flaws" in your work to others; it will rob them of joy.
- Even though you work hard at improving, don't forget to enjoy yourself while you paint. Fun is also holy.
- Skillful simplicity is the sign of a real master. The best iconographers understood that less really is more. Don't allow embellishments and details to divert attention from the essentials.
- Be gentle with yourself.

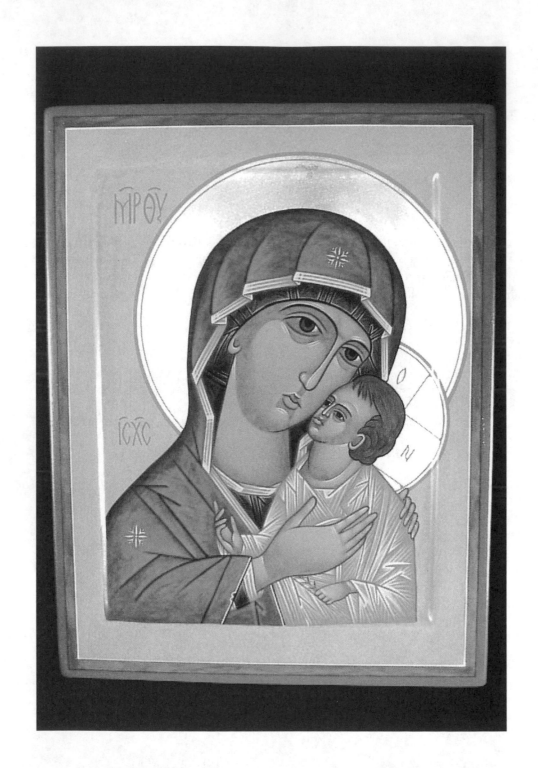

— AFTERWORD —
Retelling the Story

From the earliest days of the Christian experience, believers have searched for ways to express their faith. Our forbears did this through images enfleshed in literature, ritual, music, and art. Over time, these expressions of faith have evolved and yet remained the same in many ways. The Scriptures have been "unpacked" in numerous volumes of commentaries and homilies. Our liturgical celebrations have been adapted to the changing needs of the faithful in particular places and at specific times. Our musical preferences have changed. And our artistic attempts to express the inexpressible have developed in innumerable ways. Still the heart of the message has remained unchanged, faithful to the mission and message of the Lord Jesus.

For a believer who creates iconographic images of the Christian faith, our task has little to do with personal creativity or imagination; we're dealing with tradition, entrusted to us but never ours. We are servants to something and someone greater than we are. So we bear a significant responsibility to honesty, authenticity, and fidelity if we are to serve the community of believers.

I recently had the opportunity to sit down with several iconographers, including Robert Lentz, to share some thoughts about iconography. During our conversation, the question arose as to why we continue to create the classic images of Byzantine iconography in a time and place so far removed from that culture. Some among us felt there were more than enough copies of the ancient images and that it was time to push the boundaries a bit in order to make the images more meaningful and alive for people today. As I reflected upon why we *do* paint the same images time and time again, family stories came to mind.

When families gather, they frequently end up telling familiar stories and nevertheless listen as if they were sharing them for the very first time. We continue to tell them, and we relish the experience of hearing them. Even a reference to a familiar family story brings an experience to life again within each of us. Every family has a set of special stories that make its shared history alive and accessible. It is this act of remembering which reinforces our bonds and revitalizes our identity with an eye toward our common future.

It all comes down to remembering.

A few years ago, I was graced to attend a presentation by Sufi dervishes. As they whirled on the floor, musicians continuously chanted the Islamic name of God. After they had finished, I spoke with the woman who led the music and commented on the centering effect of the chant. I was quickly corrected. The mantra, she said, was not intended to help the dancers center themselves, but to remember. Her remarks reminded me of those of a friend, Father Andrew, who wrote the forward to this book and who teaches liturgical theology. He says the Psalms—whether they're filled with praise or complaints—are all about remembering the goodness and faithfulness of God. The act of remembering acknowledges that God is always present and active in our world. It is we who often forget this fundamental fact.

This is especially true for those who come together in the name of the Lord Jesus. Day after day and week after week, we remember by telling the stories of his miracles, his teachings, his acts of kindness, his dying, and his rising. We do this with our literature, our ritual, our music, and our art. We do this to remember, specifically to remember who we are and whose we are.

Icons visually proclaim the gospel message. Just as the Scriptures come to us through a specific culture fixed in time and place, so too, the imagery within Byzantine iconography reflects that time and culture. Few of us live in agrarian, pastoral settings similar to those in the gospels, and fewer still in anything resembling the Byzantine Empire. Yet the message of these images of faith transcends their geographic and chronological locus. They endure and provide a common point of departure for believers of any place and time. Perhaps it is this "foreignness" which makes them accessible to us: they belong to no one and everyone at the same time.

Back in the 1970s, I had a teacher whose husband was a Presbyterian minister. He was experimenting with "relevant liturgies" and once used pizza and soda to celebrate the Lord's Supper. Today, that concept seems very odd to me because it seems to trivialize the richness of the Eucharist for the sake of making it "relevant."

Our message is greater than our settings; it is greater than we are. If the message is in fact universal, the vehicles for communicating it must be powerful enough to bear the weight of the message and its mystery.

This leads me to my next point: that of mystery. Since the Western Renaissance, artists have created images of Christ, the Mother and Child, angels, and the saints based on personal inspiration or interpretation using family, friends, and acquaintances as models. Realism has reigned. And although these images are often beautiful, they tend to generate human emotion rather than invite transcendence; they're about our reality rather than God's reality. Our faith is not simply a matter of emotion and, in fact, the truths we seek to express are far beyond anything we see, feel, or understand. Mystery is always greater than the vehicles used to communicate it and every human attempt, no matter how lofty and beautiful, will be found wanting. Ultimate reality cannot be fully expressed by finite beings, but we can try. We must try. Some of our methods are more successful than others and the best of

them are the ones that endure. Gospel stories endure, the Breaking of the Bread endures, chant endures, and as we know, Byzantine icons endure.

We repeat these expressions of faith over and over again because they help us remember that God is great, that the Kingdom is for all people of all times and places, and that we are somehow a part of a greater picture than the one we see here and now. These are our family stories as they find their expression in prose, poetry, gestures, sounds, and in pictorial representations of unseen realities.

If there were any way to end this patchwork quilt of reflections, fragments, and suggestions it would be to express my most sincere prayer that this material will serve in some way. It's a real blessing for me to share what I have loved for so long and I am grateful for any opportunity to do so.

Remember that while you work on these images, they also work on you. I invite you to open your heart so that you might become perhaps a bit more like those whose images you paint. In other words, become what you already are—but even more so.

Please be gentle with yourself and reasonable in your expectations. No matter how sublimely beautiful your icons turn out, they will never fully express the unspeakable beauty of God and will always be found wanting. Still, for some of us, it is vital that we try and keep trying. After all, with all the images of bad news in the world, could we ever have enough images of the Good News?

To God be glory forever.
Amen.
Peter

— Appendix A —
A Summary of Icon Controversies

Several points of contention inevitably arise whenever icons or holy images are discussed. Here, I'll address some of these key controversies, providing opinions based on my own experience and theological study.

Idols?

In many circles, icons (as well as other forms of representational art) are dismissed as idolatry. Those espousing this view often quote verses from the Old Testament to support these claims. Coming mainly from the Reformation tradition, they tend to take a more "literal," though selective, view of Scripture. Interestingly, many of their concerns were dealt with during the Iconoclastic Controversies of the eighth through ninth centuries, with no shortage of politics and violence. The matter was resolved by the church at the Council of Constantinople in 842 A.D. The council fathers concluded that an icon is an aid to prayer, *not* the object of prayer. Veneration is offered to the one represented, not to the material reality of his or her image.

What's important to recognize is the fact that we tend to think almost exclusively in images. Pictures and words are symbolic representations that help us connect with physical or spiritual reality; they're not the realities to which they point. Why, then, are verbal images so much more worthy than pictorial forms of bearing divine presence? The faith tradition in which I was reared boldly proclaims that God is present in the Eucharist, the community of believers, the priest, as well as Scripture. I've often wondered whether this presence might also extend to Scripture rendered in icons, where story is conveyed through color and line rather than through letters and words.

As the adage goes, "the map is not the territory." Idolatry emerges only when we confuse map with territory. An icon is not an idol unless one chooses to make it so.

To whom do icons belong?

Some of our Orthodox sisters and brothers claim that real icons can only be created and venerated within their particular faith tradition. The Orthodox faithful believe icons are the gospel proclaimed. This being the case, I would argue that just as the "Good News" belongs to everyone, so too do icons.

Prior to the unfortunate break between the Eastern and Western churches in 1054, there was only one Christian church unified with a diversity of expressions. Although icons developed primarily in the East, there's much evidence to suggest that they were widely venerated in all parts of the Christian world. In fact, the treasury of the Monastery of Saint Catherine in the Sinai Desert has many icons created by Western iconographers from the thirteenth century.

Only after the Great Schism do we see a gradual evolution in the West away from Byzantine iconography into a more realistic expression of religious images (for example, the work of Italian painters such as Cimabue and Giotto).

Icons are the common artistic heritage of all Christians, not the exclusive property of any denomination. They offer all Christian believers an important area of common ground and, as such, they may provide a wonderful means for ecumenical growth.

THE ACCEPTABLE MEDIA FOR CREATING ICONS

Another point of contention among iconographers centers on issues of media, sometimes referred to as the "Egg Wars." Is it appropriate and acceptable to create an icon using anything other than egg tempera? I believe it is and many others from both the East and West share this belief.

When we survey the history of icons, it's evident that any number of materials were used to create them. In fact, the word "icon" was originally a generic term for holy images made of ivory, enamels, frescos, precious metals, wood, stone, textiles, and painted panels. The few painted icons surviving from the earliest centuries of Christianity were made by the encaustic method of using melted, colored waxes on wooden panels—a point frequently overlooked by "purists."

One of my teachers addresses this dispute simply and directly by saying: "You can make a religion out of anything, even eggs." To become mired in the endless arguments about which medium to use misses the point completely. If you can pray better by using egg tempera, then by all means do so. I find it less daunting for novices to use acrylic paints, which offer more flexibility and ease of handling.

THE THEOLOGY BEHIND ICONOGRAPHY AND THE CREATION OF AN ICON

There are many wonderful texts and teachers elucidating the beautiful spirituality and symbolism involved in the act of creating an icon. For some, these are quite complicated, almost as involved as the technical skills required. Nonetheless, they're a valuable part of the tradition and worthy of study.

One Canadian iconographer notes how we must master basic technical skills. This much is obvious. But, he insists, good iconographers must also apply themselves to study and prayer so their work will be an integrated expression of technique and theory, as well as a life of faith in service to the community of believers. Iconography, then, is much more than a "craft." It involves who we are as much as what we do.

The role of the professional iconographer is one of vocation—service within and to the Church. Preparation for this service can and should take years. Becoming an authentic iconographer is a long

63

and involved process that demands a thorough knowledge of the art and its technical requirements; the study of theology, spirituality, and history; an active immersion in the life of a community of faith; and a dedication to prayer. These last two are the most important elements in the life of an iconographer. An iconographer must be steeped in the tradition and canons of iconography. And in the world of iconography, the canons are embodied by tradition and the icons themselves. There's no formal catechism to study. Technical skill alone cannot hallow an icon. Only God can do that, and prayer is the key to making this possible.

CAN ANYONE BECOME AN ICONOGRAPHER?

Over the last fifteen years, I've met many people who begin our interactions with the exact same sentence: "I feel called to paint icons." At first, I was overjoyed to find others who shared my passion for these ancient images of Christian faith. But experience has taught me that sometimes what I'm actually hearing is a desire to start a business. This concerns me, not because I want to eliminate the competition, but because starting a business (making money) is not an appropriate reason to paint icons. Believe me, there are many less demanding ways to make a living. If you wish to paint icons, do so because you love them and because you must paint them. Respond to the invitation but don't plan the future; that's God's job.

Presently, there's no authoritative body that grants its imprimatur to budding iconographers; there is no certification process to ensure high standards. Consequently, we depend on each individual to decide if it's appropriate to claim professional status. It might be helpful to apprentice with a seasoned iconographer and work with a spiritual director, asking them to help you discern whether you're ready to claim professional status.

Study with as many teachers as you are able, from various schools. Whenever you study with a teacher, try to grasp the big picture instead of cheating yourself by focusing on producing a single icon. While you're with a teacher, do things his or her way. Good teachers will assist and encourage you to understand their particular method and invite you to adopt whatever works. You'll have time to express your individuality later.

Watch your teachers paint, but don't get so caught up in awe that you fail to learn something from what they do and how they do it. Ultimately, you must learn to paint like you, not your teacher.

WRITING VS. PAINTING

Many iconographers use the term "writing icons" when they speak of what they do, expressing a view that places iconography on a parallel with theology and Scripture. With icons we proclaim God's truth in colors and lines instead of words. Our action is similar to the monks of the middle ages who faithfully transcribed the Scriptures. As such, both they and we are servants to God's story of salvation history as it has unfolded in our Judeo-Christian faith tradition.

As I understand it, the original language spoken by Eastern Christians had only one word to express the act of marking a surface to communicate a message. In Greek this word is *"graphia"* and can mean either to write or to paint (in the modern sense of those words). English provides two separate words to distinguish jotting down thoughts in a verbal form from creating art by applying pigments to a surface. Since we have this clear distinction at our disposal, I refer to "painting icons" without intending any disrespect to my sisters and brothers who prefer to "write icons."

— APPENDIX B —
Supplies and Materials

GOLD LEAF
Art Essentials of New York
P.O. Box 38
Tallman, NY 10982-0038
800-283-5323
www.artessentialsofnewyork.com

PANELS
Innerglow Painting Panel Company
Contact: Mary Ewing
519 Brandywine Drive
West Chester, PA 19832
877-430-3639
bewing@bellatlantic.net

Stanislav Solovyev
206 Jamaica Boulevard
Endicott, NY 13760
607-754-6774
stas@iconboards.com

PAINTS
Jo Sonja Artist's Gouache
P.O. Box 9080
Eureka, CA 95501
707-445-9306
folkart@josonja.com

Golden Artist Colors, Inc.
188 Bell Road
New Berlin, New York 13411
607-847-6154
goldenart@goldenpaints.com

PAINTS AND BRUSHES
(one stop shopping)
Hofcraft
P.O. Box 72
Grand Haven, MI 49417
www.hofcraft.com

ICONS ON THE INTERNET
www.iconofile.com

— Appendix C —
Icon Worksheet

Keeping a written record of colors you use, as well as any notes about things that might be important will help you replicate this icon at a future date. Simply jot down any thoughts, questions, or observations that arise as you work. Keeping a written record will ensure that these insights are not lost while you were working.

DRAWING _____

COLOR WASH _____

BASE COATS _____

SHADOWS _____

HIGHLIGHTS _____

DETAILS _____

OUTLINING _____

Halo Template

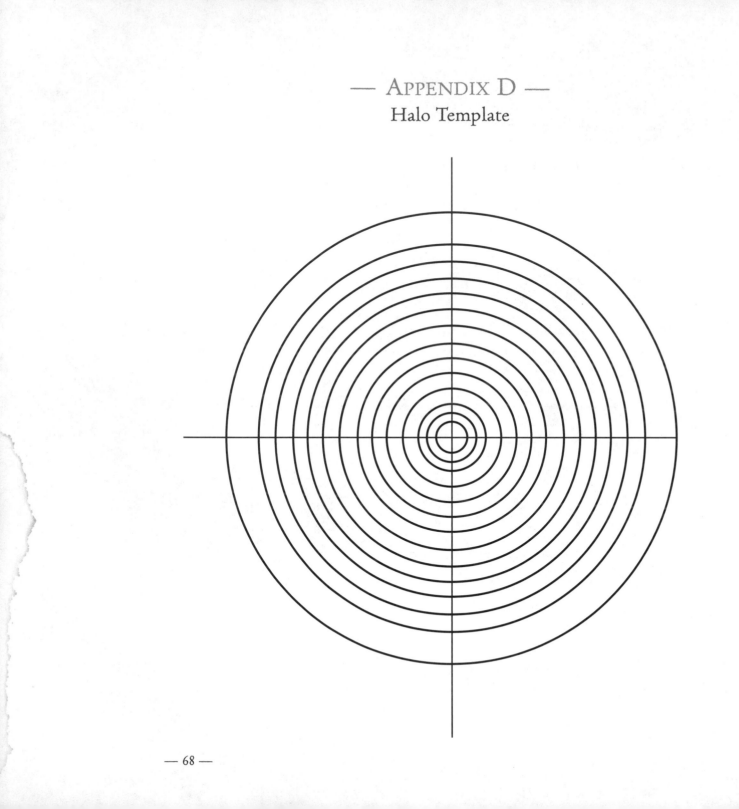

— APPENDIX E —
Highlights for Hands and Feet

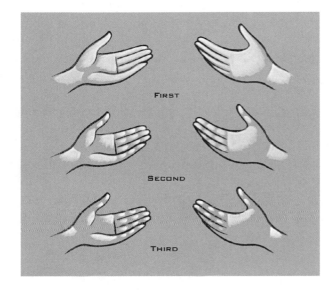

FIRST

SECOND

THIRD

FIRST

SECOND

THIRD

A Prayer for the Blessing of Icons

Leader: Creating God, you fashioned the universe in love and brought us forth from the earth.

Throughout the ages, our ancestors longed to see your face and when the time had grown full, you sent your Christ among us so that we might find our way back to you, our source and our destiny.

Look upon your servants here and upon these icons, created in love and prayer.

Fill them with the radiance of your good, holy, and life-giving Spirit to complete the work of our hands for your glory and for the good of those who will come to pray before them.

May these icons be a source of blessing and hope for your people, may they give comfort and challenge complacency, and may they proclaim your infinite love for us in every situation.

We ask this in Jesus' name.

Assembly: Amen.

The icons are then anointed with holy oil (on the back) using these or similar words:

Leader: This icon is blessed and sanctified in the name of the Father, and of the Son, and of the Holy Spirit.

Assembly: Amen.

— APPENDIX G —
Glossary of Iconography Terms

ANCIENT OF DAYS: An image of God the Father.

ANGEL: A heavenly messenger, usually portrayed with wings.

ARCHANGEL: A rank of angels including Michael, Gabriel, Raphael, and so on.

ARCHEIEROPOIETOS: An image "not made by human hands," such as the face of Jesus on the cloth or the Guadalupe image of Mary.

ARCHIMANDRITE: The abbot of a monastery.

AUREOLE: A visual reference to heaven in the form of a semi-circle, circle, or elliptical shape.

BURNISH: To polish gold leaf with cotton or a special polishing tool.

CANON(S): The standards of measure or rules of iconography.

CHERUBIM: One of the ranks of angels with six wings and frequently rendered in blue.

CLAVIUM: The shoulder stripe on a tunic or under-garment worn in the Roman/Byzantine Empire as a sign of social status.

COPTIC: Egyptian Christianity encompassing much of North Africa as well as the term for the style of iconography peculiar to that region.

CRUCIFIX: A cross with a representation of the crucified figure of Christ on it.

DEISIS: A supplication grouping with Christ or the Mother of God at its center with saints, angels, or prophets bowing on either side.

DEMATERIALIZATION: The stylistic manner of removing the human figure from realistic representation in order to communicate the spiritual as well as the physical.

DIVINIZATION: The Eastern spiritual concept of God becoming human in order that we might become like God.

DOUBLE REFLECTION: A method of highlighting garments that uses a completely different color to create a special effect of radiance.

EGG TEMPERA: The painting medium created by mixing pigments with the contents of the yolk sack of an egg along with a preservative.

ENCAUSTIC: The painting medium created by mixing pigments with melted wax; employed in many of the earliest panel icons.

ENLIVENERS: Small, light hatch lines used to create the brightest highlights on skin areas.

FAMILY ICON: An image that includes the patron saints of a specific family.

FLOAT: A technical term used by some iconographers to refer to something like a color wash over an area within an icon.

FOOLS/HOLY FOOLS: A category of saints, particularly loved in Russia, known for their prophetically ascetic lives.

FORERUNNER: The title given to John the Baptist in the Eastern church.

GLAZE: A translucent layer of color, created by combining a medium with pigment, applied over an area of an icon.

GREEK: A general term for one of the major styles in iconography; includes icons from most of the Mediterranean area.

HALO: Light emanating from a holy person, usually rendered as a circle of gold around the head.

HESYCHISM: The contemplative spirituality of the silence of God practiced by many who pray the Jesus Prayer.

HODEGETRIA: Literally "she who points the way," which is one of the main types of images of the Mother of God.

HOLY DOORS: The center doors of the iconostasis through which only the priest may pass while serving the liturgy.

HOLY FACE: The image of the face of Jesus on the cloth; known in the West as "Veronica's Veil."

ICONOCLAST: An icon breaker, someone who opposes images of the divine.

ICONODULE: One who supports the creation and use of images of the divine.

ICONOSTASIS: Literally "the place where the icons stand"; the wall of icons between the sanctuary and the nave of an Eastern church.

INVERSE PERSPECTIVE: The method of creating the illusion that objects appear larger as they move further away from the viewer of an icon.

ISPOD: The inner garment.

JESUS PRAYER/PRAYER OF THE HEART: An Eastern Christian mantra prayer practiced in conjunction with the breath.

LORD SABBAOTH: A representation of God the Father found in some icons, suppressed by the Russian Orthodox Church several centuries ago because it is purely a fabrication of the artist's imagination rather than a scriptural image.

MANDYLION: The image of Christ's face on the cloth.

MANDORLA: See "AUREOLE."

MAPHORION: The outer garment, a shawl-like veil, worn by women in iconography.

MITRE: The crown-like hat worn by Eastern bishops and other designated priests.

OLIPHA: A varnish made of boiled linseed oil along with some other additives.

OMOPHORION: The white scarf overlaid with crosses worn by Eastern bishops.

ORANS: A posture of prayer in which the hands are raised to shoulder height.

PANAGIA: The small cameo icons worn by some priests and bishops.

PANTOCRATOR: A title for Christ meaning "ruler of all."

PECTORAL CROSS: The cross worn by bishops and designated priests as a sign of office.

PETIT LAC: Literally "small lakes"; a puddling method of painting base coats.

PLATYTERA: Literally "more spacious than the heavens"; this is an icon of the Theotokos of the Sign placed in the apse of the church.

PRAYER CORNER/RED CORNER, BEAUTIFUL CORNER, ICON CORNER: The domestic shrine for prayer.

PROPLASMOS: Literally "first skin"; the base color for skin in iconography (see "SANKIR").

PUDDLE: A method of painting in which generous amounts of paint are applied in an area and allowed to dry rather than being spread out over a larger area (see "PETIT LAC").

RECLUSE: A hermit.

RELIC: A part of the body of a saint or something related to them that serves as a blessing.

RIZA: The outer garment and/or the metal cover placed over an icon.

RUSSIAN: A general term for one of the styles of iconography related to most of northeastern Europe.

SAKKOS: A tunic-like garment worn by some bishops in place of the chasuble.

SANKIR: The base color for skin areas (see "PROPLASMOS").

SCHEMA/GREAT SCHEMA: A hooded scapular with the symbols of Christ's passion embroidered upon it; worn by only the holiest monastics.

SERAPHIM: A rank of angels represented as having six wings and usually rendered in red.

SHOWER CAP: The turban-like head gear worn by Byzantine women under the maphorion.

SIGN: One of the major types of icons of the Theotokos.

SLAVONIC: The liturgical language used in northeastern Europe.

SPLINES: The hardwood pieces inserted into the back of a solid icon panel for the purpose of counteracting warping.

SYNAXIS: Literally, "the gathering" or "assembly" of a group of figures in an icon.

TENDERNESS: One of the major types of icons of the Mother of God, in which the cheeks of Mary and the child Jesus are pressed together.

THEOSIS: See "DIVINIZATION."

THEOTOKOS: Literally "God bearer"; a title for Jesus' mother, Mary.

TROPARION/TROPAR: A short antiphonal prayer.

VERNICLE: The icon of the face of Christ on the cloth; also known as the Holy Face.

WASH: An application of diluted paint similar to watercolor in consistency.

WONDER WORKING: A title given to icons credited with miraculous occurrences such as healings and conversions, or which weep myrrh.

— Appendix H —
Selected Readings

Alpatov, M.V. *Early Russian Icon Painting*. Moscow, Iskusstvo, 1978.

Berrigan, Daniel. *The Bride: Images of the Church*. Maryknoll, N.Y.: Orbis Books, 2000. (ISBN 1-57075-305-9)

Chittister OSB, Joan. *The Friendship of Women: A Spiritual Tradition*. Franklin, Wis.: Sheed & Ward, 2000. (ISBN 1-890890-10-3)

Collins OSB, Gregory. *The Glenstal Book of Icons: Praying with the Glenstal Icons*. Blackrock, Ireland: The Columba Press, 2002. (ISBN 1-85607-362-9)

de Vyver, Jane Merriam. *The Artistic Unity of the Russian Orthodox Church: Religion, Liturgy, Icons and Architecture*. Belleville, Mich.: Firebird Publishers, 1992. (ISBN 1-881211-01-0)

Forest, Jim. *Praying with Icons*. Maryknoll, N.Y.: Orbis Books, 1997. (ISBN 1-57075-112-9)

Hart, Russell. *Communing With the Saints*. Springfield, Ill.: Templegate Publishers, 1994. (ISBN 0-87243-203-3)

Heldman, Marilyn, and Stuart C. Munro-Hay. *African Zion: The Sacred Art of Ethiopia*. New Haven and London: Yale University Press, 1993. (ISBN 0-300-05819-5 and ISBN 0-300-05915-9)

Juzj, Maria Giovanna. *Transfiguration: Introduction to the Contemplation of Icons*. Boston, Mass: St. Paul Books & Media, 1991. (ISBN 0-8198-7350-0)

Kostsova, A. *The Subjects of Early Russian Icons*. St. Petersburg, Iskusstvo Publishers, 1994.

Lasarev, V. N. *The Double-Faced Tablets from the St. Sophia Cathedral in Novgorod: Pages from the History of Novgorodian Painting*. Moscow: Iskusstvo Art Publishers, 1973.

Likhachov, Dimtry, Vera Lavrina, and Vasily Pushkariov. *Novgorod Icons: 12th–17th Centuries*. Leningrad: Aurora Art Publishers, 1980, 1983.

Markelov, Gleb. *Russian Icon Designs: A Compendium of 500 Canonical Imprints and Transfers of the Fifteenth to Nineteenth Centuries*.2 vols. St. Petersburg: Ivan Limbakh Publishing House, 2001. (ISBN 5-89059-004-9)

Martin, Linette. *Sacred Doorways: A Beginner's Guide to Icons*. Brewster, Mass.: Paraclete Press, 2002. (ISBN 1-55725-307-2)

Maxym, Lucy, ed. *The History and Art of the Russian Icon from the X to the XX Centuries.* Farmingdale, N.Y.: Frank C. Toole & Sons, Inc., 1986. (ISBN 0-940202-06-9)

McKenna, Megan. *Mary, Mother of All Nations.* Maryknoll, N.Y.: Orbis Books, 2000 (ISBN 1-57075-325-3)

Nes, Solrunn. *The Mystical Language of Icons.* London: St. Paul's Publishing, 2000. (ISBN 085439-584-9)

Nowen, Henri J. M. *Behold the Beauty of the Lord: Praying with Icons.* Notre Dame, Ind.: Ave Maria Press, 1987. (ISBN 0-87793-356-1)

Onasch, Konrad, Annemarie Schneiper, and Daniel Conklin, trans. *Icons: The Fascination and the Reality.* New York: Riverside Book Company, Inc., 1997. (ISBN 1-878351-53-2)

Ouspensky, Leonid and Vladimir Lossky. *The Message of Icons.* Crestwood, N.Y.: St. Vladimir's Seminary Press, 1983. (ISBN 0-913836-77-X and 0-913836-99-0)

Proud, Linda. *Icons: A Sacred Art.* Norwich, UK: Pitkin, 2002. (ISBN 0-85372-990-5)

Quenot, Michael. *The Resurrection and the Icon.* Crestwood, N.Y.: St. Vladimir's Seminary Press, 1997. (ISBN 0-88141-149-3)

Saint Theodore the Studite,. *On the Holy Icons.* Translated by Catharine Roth. Crestwood, N.Y.: St. Vladimir's Seminary Press, 1981. (ISBN 0-913836-76-1)

Sendler, Egon. *The Icon: Image of the Invisible.* Redondo Beach, CA: Oakwood Publications, 1998. (ISBN 0-9618545-0-2 and ISBN 0-9618545-1-0)

Talbot-Rice, T. *Icons.* Secaucus, N.J.: Wellfleet Press, 1990. (ISBN 1-55521-632-3)

Taylor, John. *Icon Painting.* New York: Mayflower Books, Inc., 1979. (ISBN 0-8317-4813-3 and 0-8317-4814-1)

Timchenko, S.V. *Russian Icons Today.* Moscow: Sovremennik, 1994. (ISBN 5-270-01477-7)

Tregubov, Andrew. *The Light of Christ: Iconography of Gregory Kroug.* Crestwood, N.Y.: St. Vladimir's Press, 1990.

Weitzman, Kurt, Gaianne Alibegasvili, Aneli Volskaja, Manolis Chatzidakis, Gordana Babic, Mihail Alpatov, Teodora Voinescu. *The Icon.* New York: Alfred A. Knopf, 1982.

Weitzman, Kurt, Manolis Chatzidakis, Sventozar Radojcic. *Icons.* New York: Alpine Fine Arts Collection, Ltd., undated. (ISBN 0-9333516-07-X)

Zaczek, Iain. *The Art of the Icon.* London, UK: Studio Edition, 1994. (ISBN 1-85891-178-8)

Zibawi, Mahooud. *The Icon: It's Meaning and History.* Collegeville, Minn.: The Liturgical Press, 1993. (ISBN 0-8146-2264-X)

— COMMISSIONING AN ICON —

Most of my work is commissioned. The original icons I create are produced according to the ancient processes and canons of traditional iconography with modern materials (for example, acrylic paint) on cabinet-quality birch plywood. Subjects and prices can be discussed by email or telephone.

You may commission an icon in either the Greek or Russian style and I can provide some basic information about these upon request. If you have a specific image in mind, providing a copy will simplify the process. Although I use panels sized in keeping with traditional proportions, other shapes and sizes are available, as are panels with raised borders. Naturally, the more complex the materials and preparation, the higher the price.

Prices for an icon usually start at about $400 for a simple composition on a 9"x12" panel, excluding shipping, delivery, packing, insurance, and tax. Please keep in mind that this is original art and that the process takes time. My backlog of work runs approximately one year and it's very important to me to keep my word to those who have already placed orders with me. If you have an urgent request, an additional fee will apply. I am frequently asked how long it takes to produce an icon. There's no simple answer to that question. Some take only a few weeks to complete and others take months.

For larger commissions, I'm able to create sketches, do research, and make presentations for a fee that will be applied to the final cost should you decide to proceed with the project. Please keep in mind that renderings are merely approximations of the finished work. If you have any questions, please don't hesitate to contact me.

I am unable to offer prints at this time.

— CONTACT INFORMATION —

PETER PEARSON

pearson@nb.net

website: www.nb.net/~pearson

— About the Author —

PETER PEARSON has been a student of iconography for over thirty years. Self taught for nearly fifteen years, in 1984 he studied with Russian iconographer Dr. Nina Bouroff in Bethesda, Maryland. After moving to Pennsylvania in 1991, Peter worked and studied with Philip Zimmerman at the Saint John of Damascus Academy of Sacred Arts, an Orthodox school of icon painting in Ligonier, Pennsylvania where he assisted in several projects and classes. In 1994, he studied with Nicholas Papas in Greensburg, Pennsylvania and in 1997, he attended the Iconography Institute at Mount Angel Abbey in Oregon, where he studied with Charles Rohrbacher of Juneau, Alaska. On several trips to the Northwest, he worked with iconographers from that area and learned about their techniques. In 2000, 2001, and 2002 Peter studied with Valentin Streltsov of Toronto, Ontario.

Peter has created hundreds of icons for private collectors, churches and other institutions throughout the world. He has made presentations on iconography to a wide variety of groups including elementary school children, college classes, art leagues, and senior citizen groups. Peter offers courses, workshops, and retreats throughout the United States, focusing on the technical skills involved in icon painting, as well as the spirituality of creating an icon. His passion for this art is obvious and highly engaging.

In addition to iconography, Peter studied architectural drafting and color at the International Institute of Design in Washington, D.C., and theology, with a specialization in liturgical studies, at Saint John's School of Theology in Boston, Georgetown University and at Saint Vincent Seminary in Latrobe, Pennsylvania, where he graduated *magna cum laude*, completing a Master of Divinity degree in 1995. His coursework included specialized studies on the history of church architecture and liturgical vesture, the role of art in worship, as well as a full year on liturgical consultation.

Peter has worked on many projects as a liturgical artist and consultant, designing worship spaces, furnishings, vesture, and seasonal decorations. In every aspect of his work, he seeks to combine sound liturgical practice with quality artistic design. Peter is a priest of the Diocese of Bethlehem, Pennsylvania.

— SELECTED MAJOR WORKS —
(These are all large, church-sized icons ranging from 2' to 8'.)

All Saints Episcopal Church, Kitty Hawk, SC: Mother of God with Saints

Archdiocese of Baltimore, Cardinal's Office: Icon for the July 2000 international meeting between the Orthodox and Catholic Churches in Emmitsburg, MD

East Liberty Presbyterian Church (Taize Community), Pittsburgh, PA: Coptic Icon of Christ and Abba Menas

Fatima Retreat Center, Dalton, PA: Mother of God of Tenderness

Grace Episcopal Church, Allentown, PA: Vladimir Mother of God

Grace Episcopal Church, Pittsburgh, PA: Entombment with Saints Mary Magdalene and Joseph of Arimathea, Mother of God with Archangels Michael and Gabriel, Crucifix, Altarpiece, and other selected icons

Holy Ghost Parish, Vinita, OK: Saints. Paul, William, Louis, and Francis

Holy Rosary Parish, Edmonds, WA: Desis grouping, Saint Vincent de Paul, and various feast day icons

Immaculate Conception Parish, Colville, WA: Resurrection, Christ Enthroned, and Crucifix

Marmion Abbey, Chicago, IL: Saint Joseph with Scenes from His Life

Newark Abbey, Newark, NJ: Presentation of the Mother of God

New Melleray Trappist Abbey, Peosta, Iowa: Holy Trinity

Our Lady of Fatima Church, Spokane, WA: Christ in Glory

Passionist Sisters of the Earth, Weston, VT: Christ the Teacher

Poor Handmaids of Jesus Christ, Donaldson, IN: Blessed Catherine Kasper

Prince of Peace Parish, Edgewood, MD: Smolensk Mother of God

Queen of Peace Parish, Salem, OR: The Holy Trinity

Queen of Peace Parish, Issaquah, WA: Crucifix and Holy Trinity

Redeemer Lutheran Church, Bettendorf, IA: Mother of God of Tenderness and Myrrh-bearing Women at the Tomb

Sacred Heart Parish, Evart, MI: Mother of God Pointing the Way

Saint Anne's Parish, Mackinac Island, MI: Vladimir Mother of God

Saint Augustine Church, Spokane, WA: Detail from Transfiguration

Saint Benedict's Monastery, Madison, WI: Christ Enthroned and The Hospitality of Abraham and Sarah

Saint Catherine's Parish, Moscow, PA: Mother of God of Tenderness

Saint Charles Borromeo Parish, Skillman, NJ: Deisis (eleven panels)
Saint John's Abbey, Collegeville, MN: Emmaus Icon with Saints Benedict and John, Saint Leo the Great
Saint John the Baptist Byzantine Catholic Church, Hazelton, PA: New Iconostasis with forty icons
 of varying sizes and shapes
Saint John/Holy Angels Parish, Newark, DE: Processional cross
Saint Joseph's Parish, Hyattsville, MD: Altarpiece (Crucifixion, Nativity, Washing of the Feet,
 Resurrection, Emmaus), Stations of the Cross, and devotional icons
Saint Joseph's Parish, Vancouver, WA: Mystical Supper, Pentecost, Nativity, Resurrection
Saint Luke's Parish, Stroudsburg, PA: Saint Luke
Saint Martin de Porres Parish, McKeesport, PA: Saint Martin de Porres
Saint Mary's Abbey, Norristown, NJ: Saint Catherine of Siena, Saint Joseph, Christ the Teacher,
 Mother of God of Tenderness, Saints Peter and Paul, Saints Benedict and Scholastica
Saint Norbert's Abbey, Paoli, PA: Mother of God of the Sign with Saints Augustine and Norbert,
 Crucifix
Saint Paul the Apostle Episcopal Church, Savannah, GA: Holy Wisdom with Theotokos and
 Saint John
Saint Peter's Parish, Galveston, TX: Saint Peter
Saint Peter in Chains Cathedral, Cincinnati, OH: Elijah in the Desert
Saint Stanislaus Parish, Summit Hill, PA: Saint Stanislaus and Christ Enthroned
Saint Thomas Episcopal Church, Oakmont, PA: Saint Nicholas
Saint Vincent's Archabbey, Latrobe, PA: Saints Benedict and Scholastica
Santa Maria del la Vid Priory, Albuquerque, NM: Pentecost Icon and Saint John the Forerunner
Teresian House Nursing Home, Albany, NY: Archangels Gabriel and Michael
Theological College, Washington, DC: Processional Cross, The Holy Trinity, Saints Teresa of Avila,
 Therese of Lisieux, and Theresa Benedicta, Saints James, Humberto, Joseph, and Augustine
 of Hippo
Trinity Episcopal Cathedral, Pittsburgh, PA: Christ Enthroned

Major Exhibits
Pecos Benedictine Abbey, Pecos, NM
Rosemont College, Philadelphia, PA
Saint Norbert's Abbey, Paoli, PA
Sandscrest Retreat Center, Wheeling, WV
Washington Theological Union, Washington, DC

— NOTES —

1. *Book of Blessings: The Roman Ritual* (Collegeville, MN: The Liturgical Press, 1989), 467.

2. Alejandro R. Garcia-Rivera, *A Wounded Innocence: Sketches of a Theology of Art* (Collegeville, MN: The Liturgical Press, 2003), 19, 58.

3. The recommended dimensions are in a 3:4 ratio (e.g., 6"x8", 9"x12", 12"x16" . . .)

4. This is mostly a matter of personal preference. It's not essential unless you're using all natural materials (e.g. egg tempera).

5. Father Egon Sendler, *The Icon: Image of the Invisible* (Redondo Beach, CA: Oakwood Publications, 1998).

6. The way in which the colors are built up can also add to the dematerialized quality of a person in an icon. When the colors are translucent, they seem to melt away as the light passes through the pigments and is reflected off the white gesso ground of the panel, bouncing back toward the viewer.

7. Naturally, there have been many spiritual interpretations offered for their existence, but I contend that most of what we do has practical origins that were given loftier rationales after the fact.

8. You can statically charge a camel hair brush by passing it over your hair.

9. Includes ancient Mediterranean countries of Byzantium, Crete, Cyprus, Mt. Athos, Serbia, Romania, etc.

10. Includes the Russian schools of Moscow, Novgorod, Eskov, Yaroslavl, and the Kiev School of the Ukraine.

11. Includes Egypt, Ethiopia, and even Georgia and Armenia.

12. Old Slavonic is the Russian equivalent of Ecclesiastical Latin.

13. You may also try this exercise with pencils, pastels, or crayons instead of watered-down color.

14. This is done by highlighting the edges of a long fold, then making diagonal swaths of light in the middle to join the two edges.

15. I often describe this color as "buttercup" and students know exactly what I mean!

16. Be careful! Inconsistency will make the eyes appear crossed.